I have a deep love and respect for children – I am a photographer, this is what I do.

You are a marvel. Each second we live is a new and unique moment of the universe, a moment that will never be again ...And what do we teach our children? We teach them that two and two make four, and that Paris is the capital of France. When will we also teach them what they are? We should say to each of them: Do you know what you are? You are a marvel. You are unique. In all the years that have passed, there has never been another child like you. Your legs, your arms, your clever fingers, the way you move. You may become a Shakespeare, a Michelangelo, a Beethoven. You have the capacity for anything. Yes, you are a marvel. And when you grow up, can you then harm another who is, like you, a marvel? You must work — we must all work — to make the world worthy of its children.

Pablo Casals

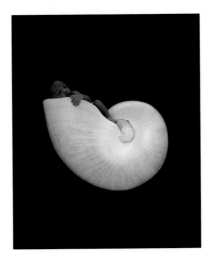

*This book is dedicated
with love to my husband, Kel, and to our
daughters, Stephanie and Kelly, who will
always be my own very special babies.*

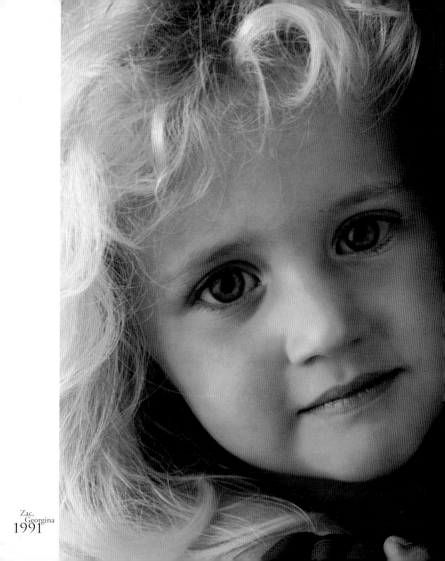

Zac,
Georgina
1991

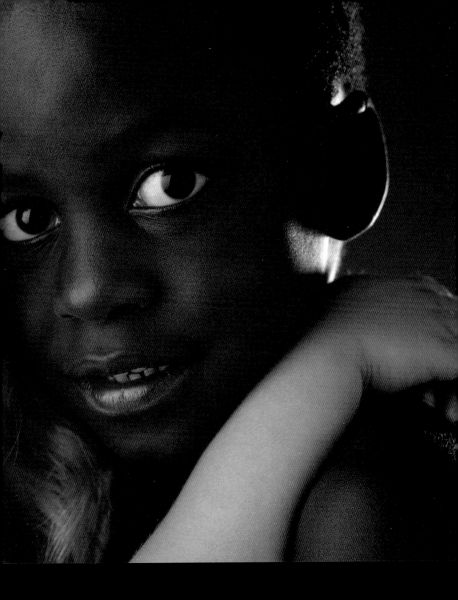

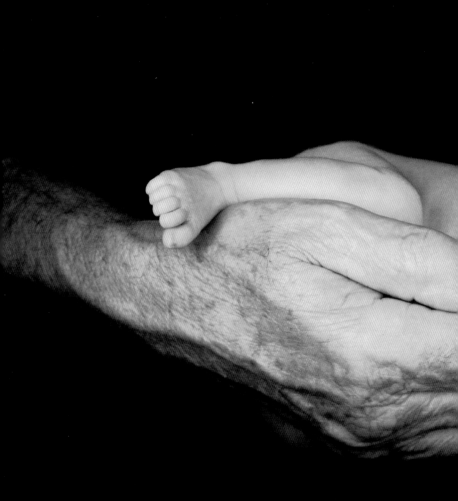

Jack holding Ariana
1997

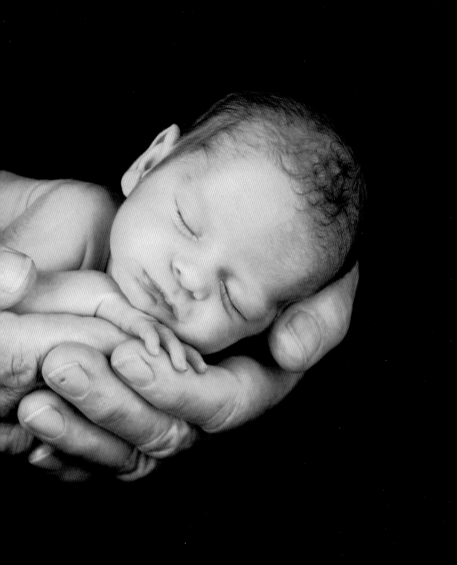

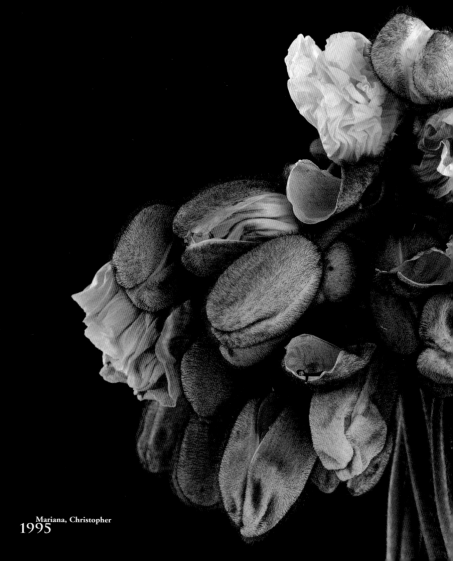

Mariana, Christopher
1995

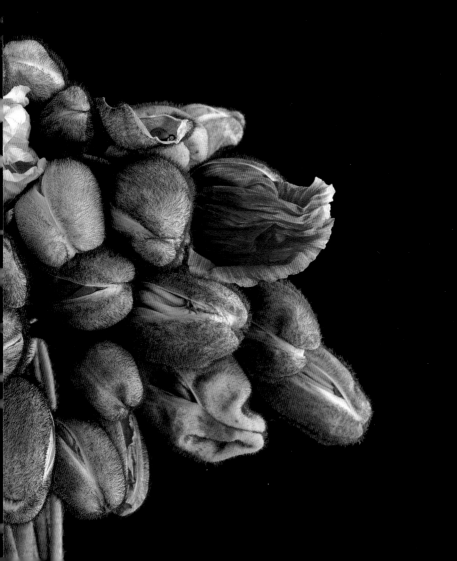

Amelia Rose
1993

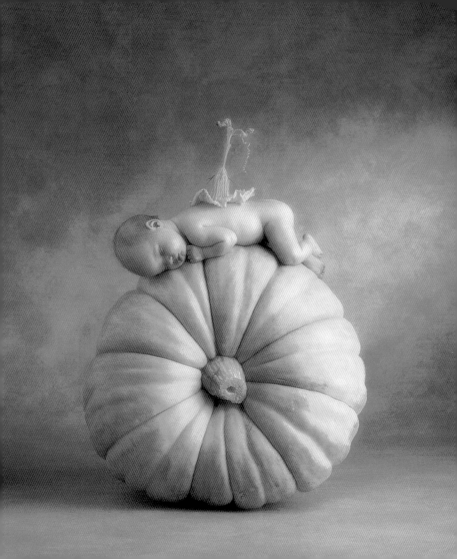

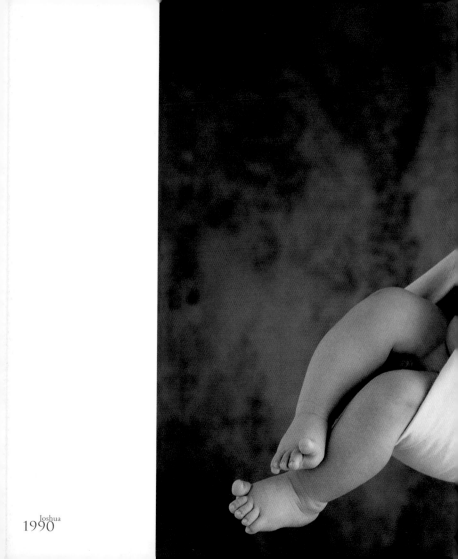

Joshua
1990

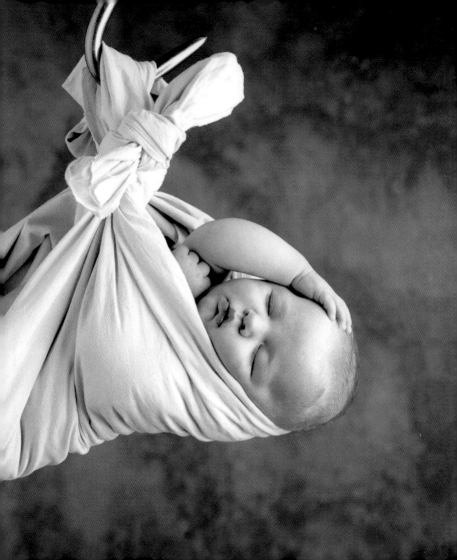

Phillipa
1992

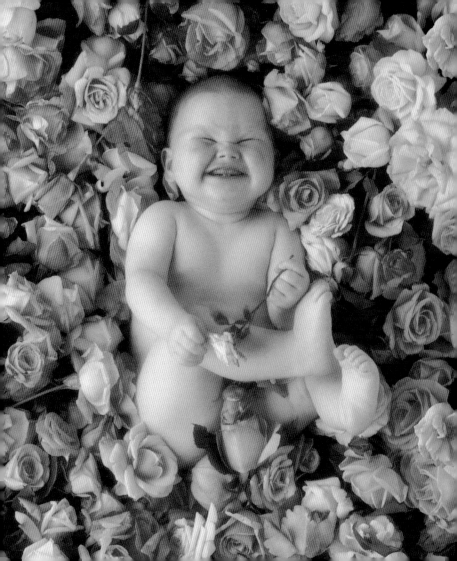

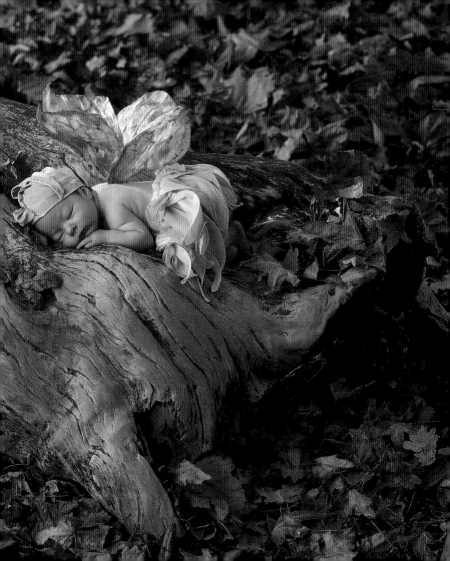

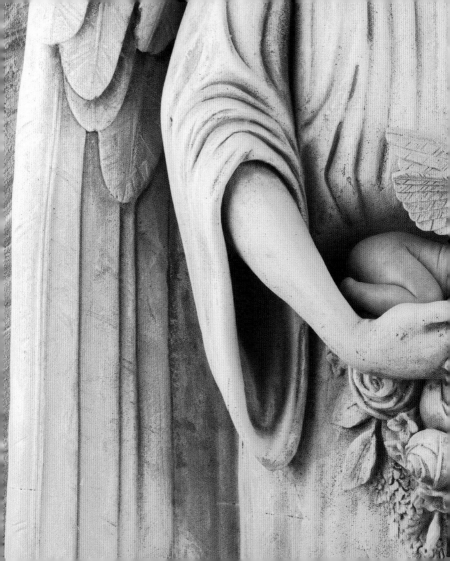

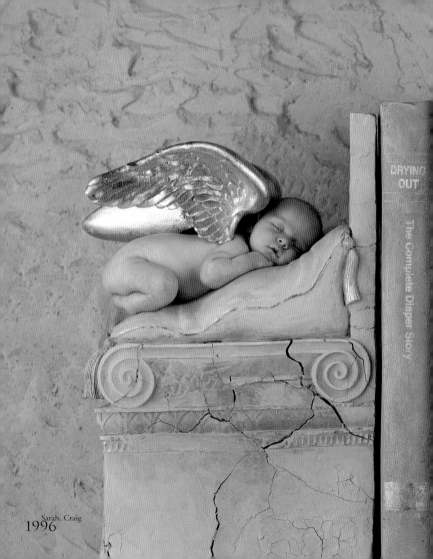

DRYING OUT

The Complete Diaper Story

Sarah, Craig
1996

Jonti
1996

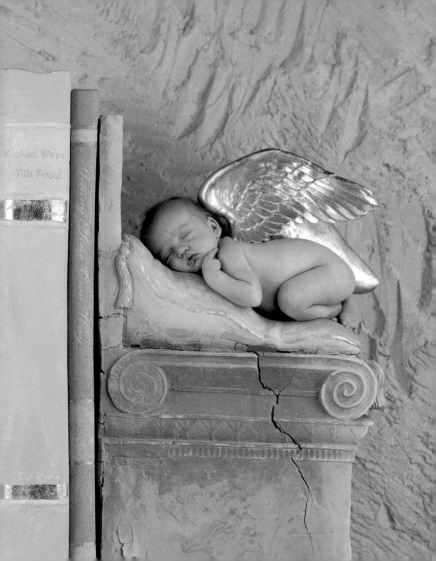

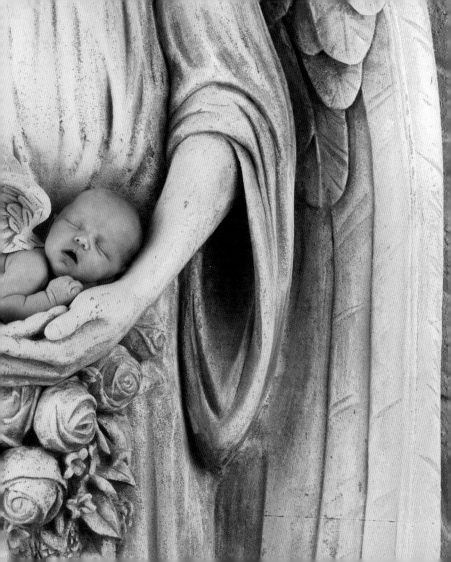

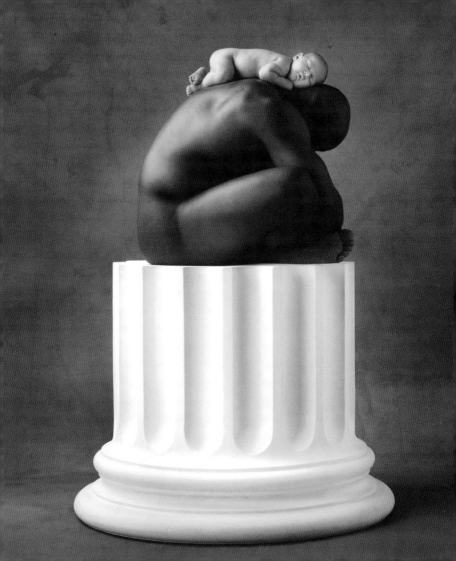

Callum, Sam
1994

Eddie, Scott, Sean
1993

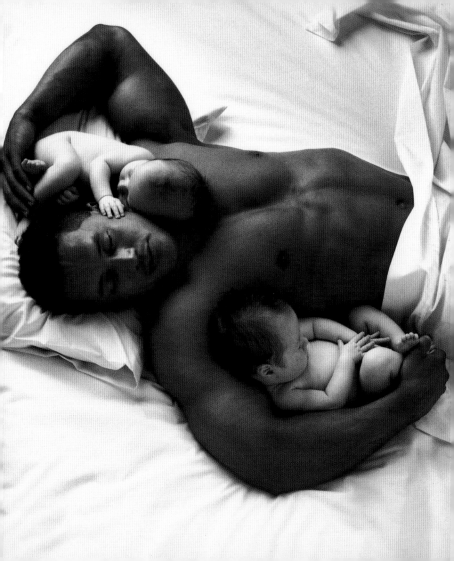

Rebecca, Courtney
1997

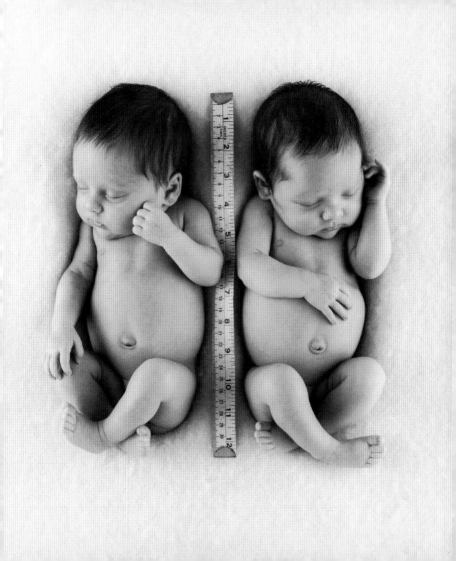

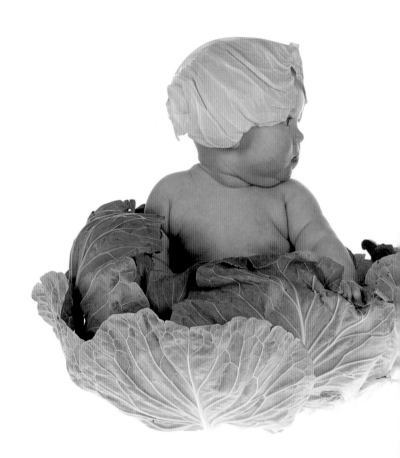

Rhys, Grant
1991

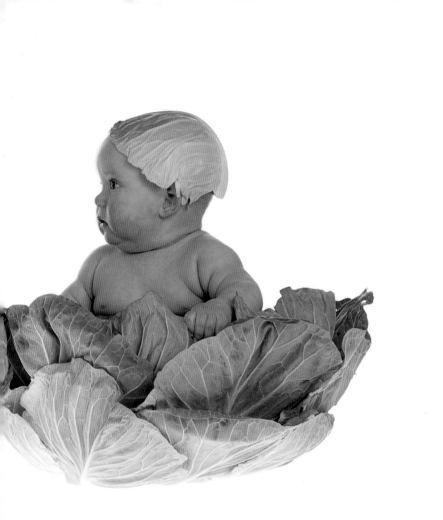

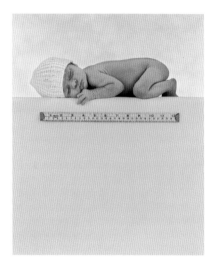

Milly Olivia Rose
1997

Milly
Olivia Rose

6 lbs 10 oz

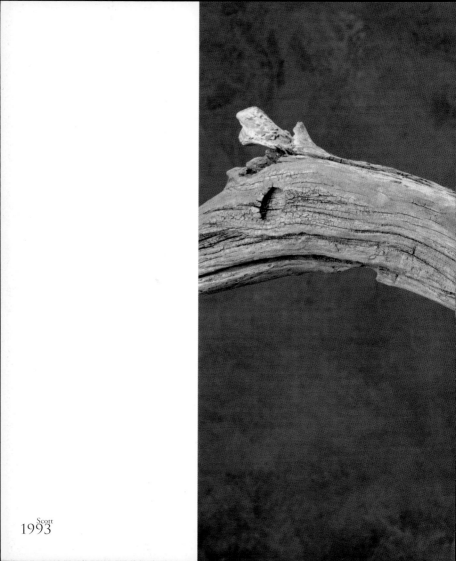

Scott
1993

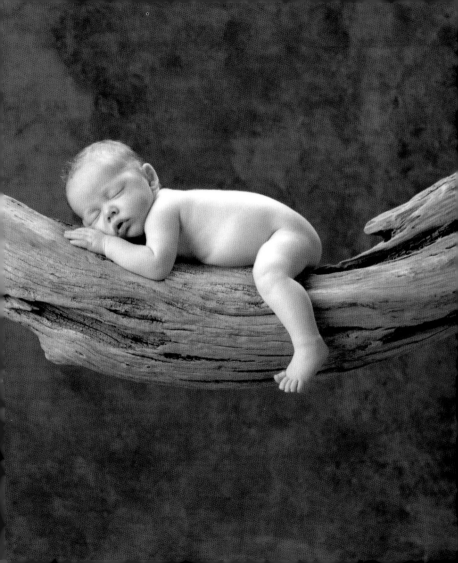

Caleb
1997

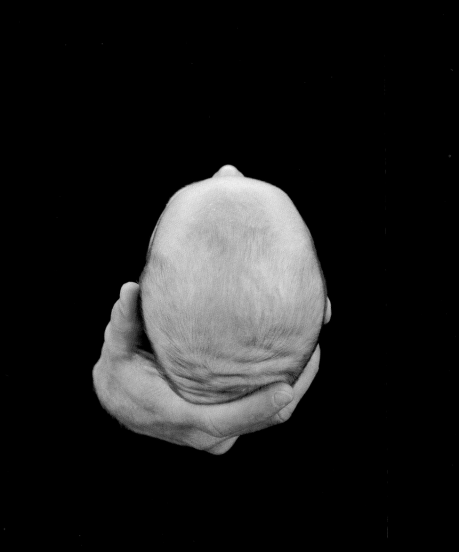

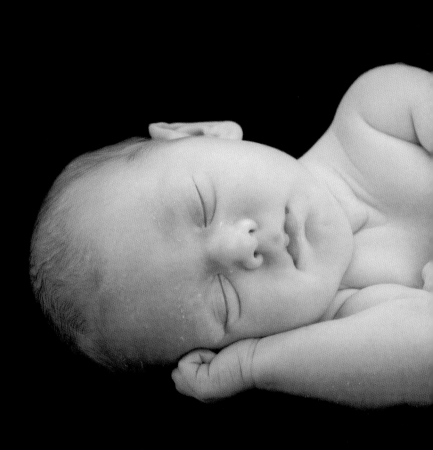

Caleb
1997

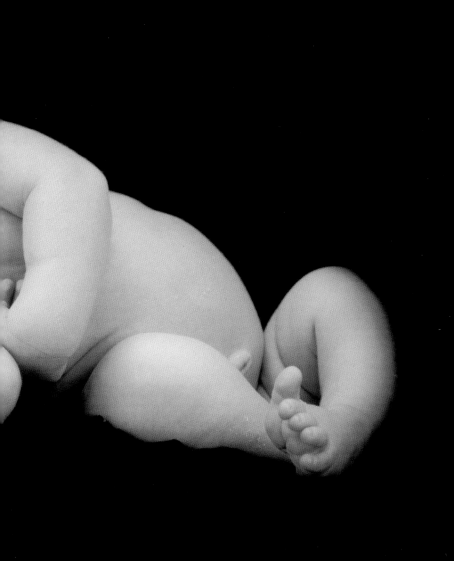

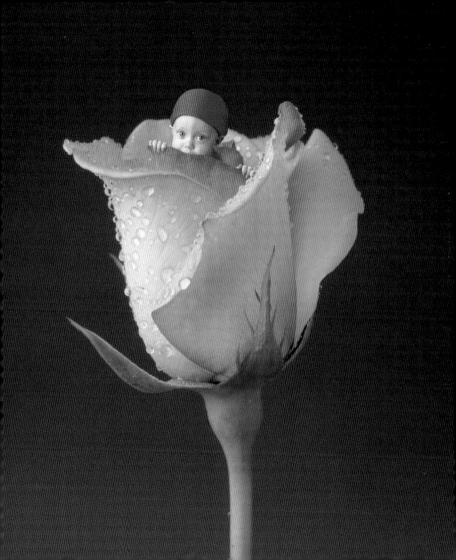

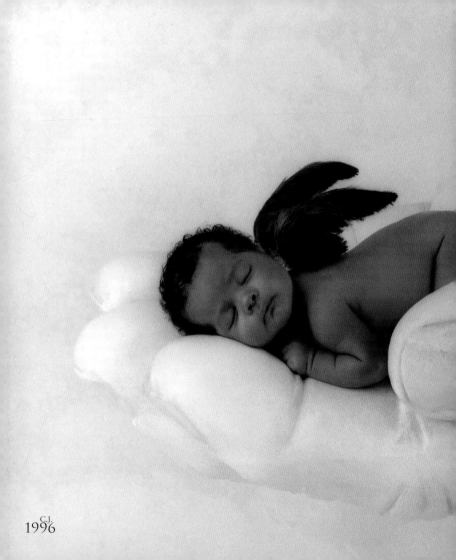

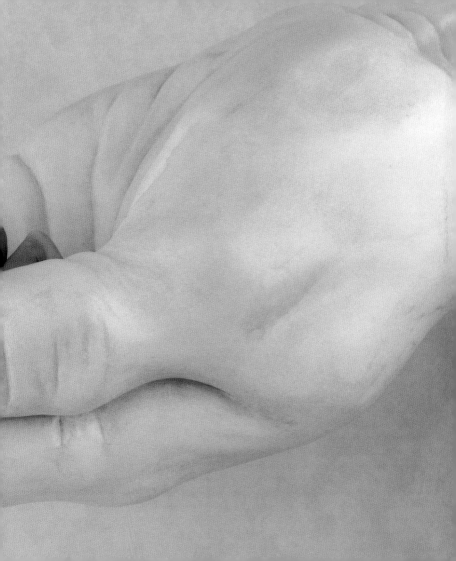

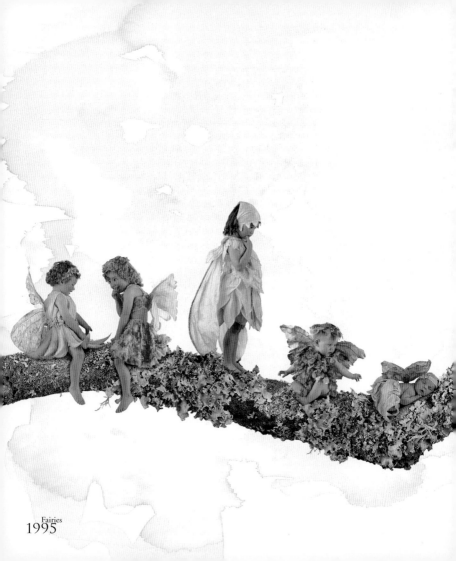

Fairies
1995

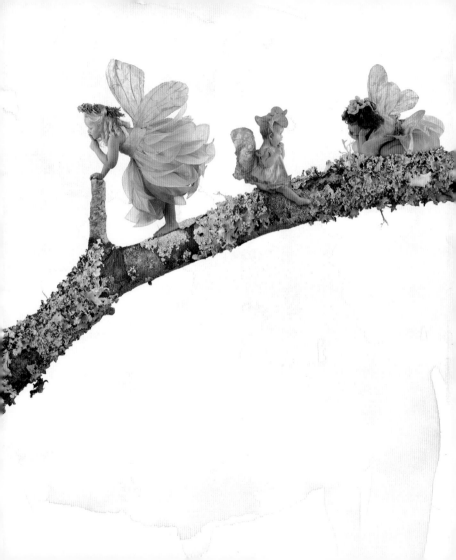

Julia
1994

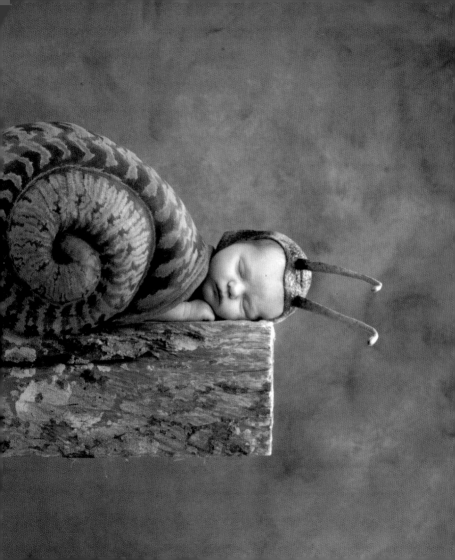

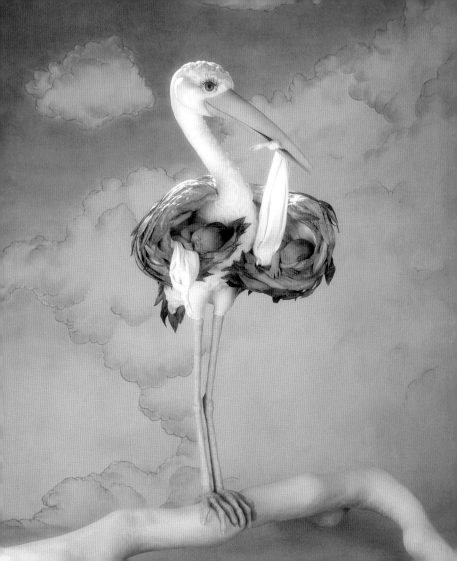

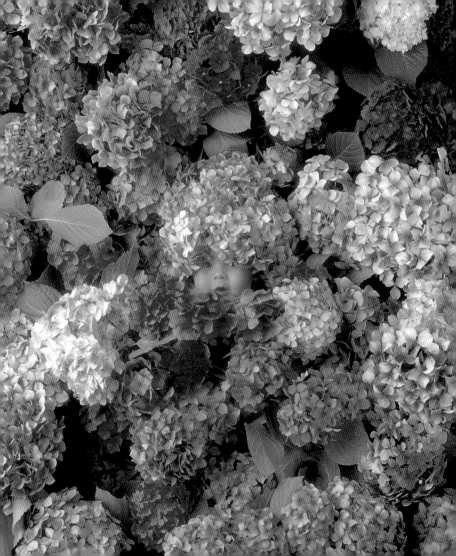

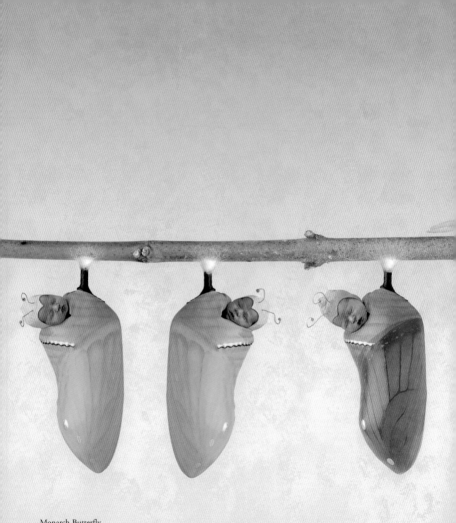

Monarch Butterfly
1995

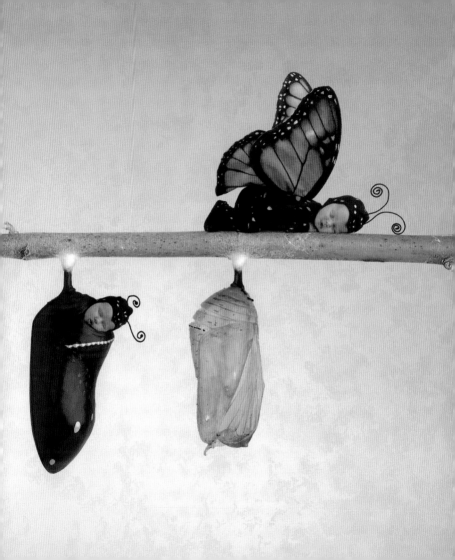

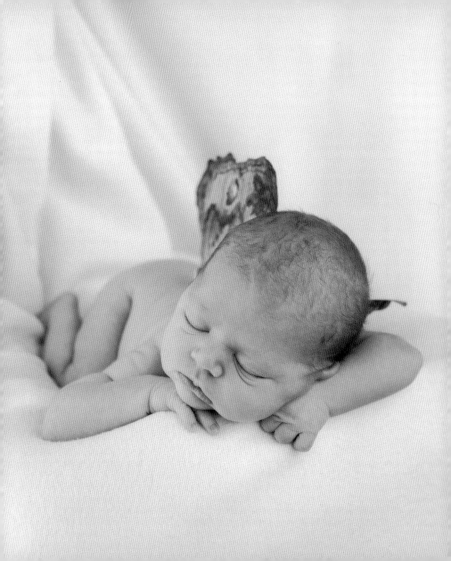

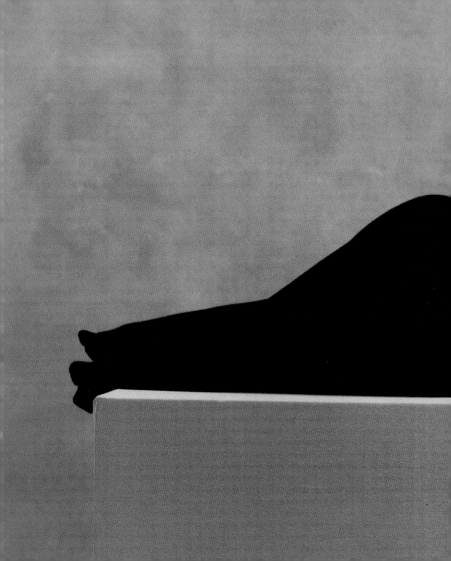

When a candle burns so bright,

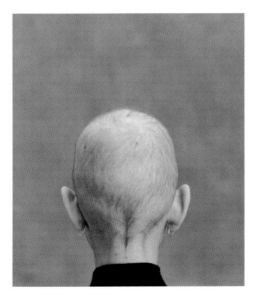

surely it cannot burn for so long. Proverb

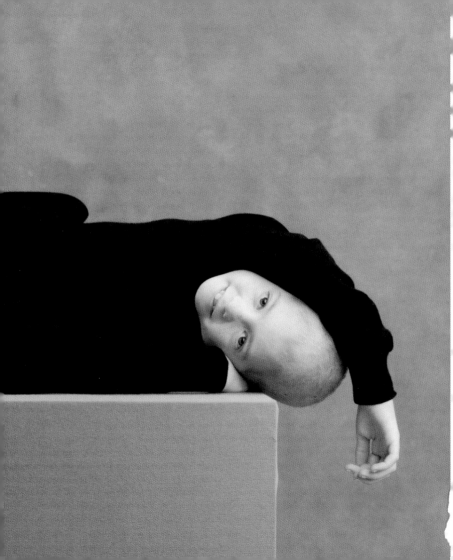

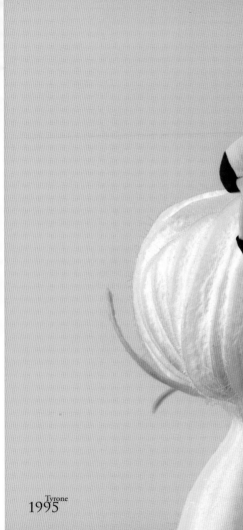

Tyrone
1995

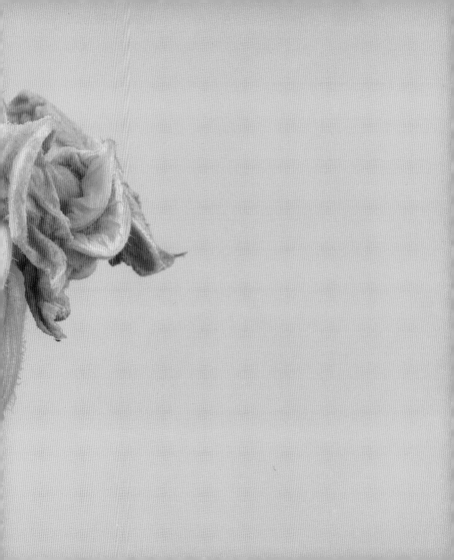

Gemma, Amelia Rose
1993

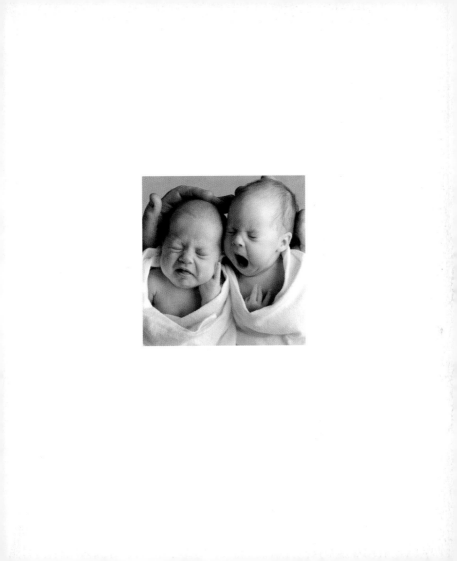

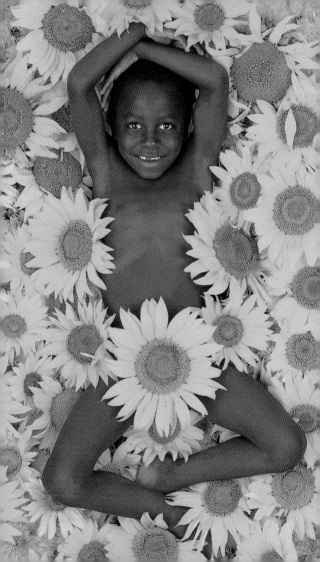

1993 Clowns

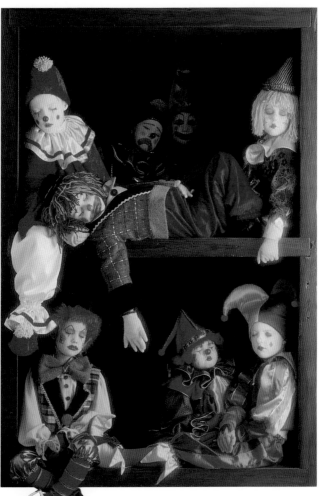

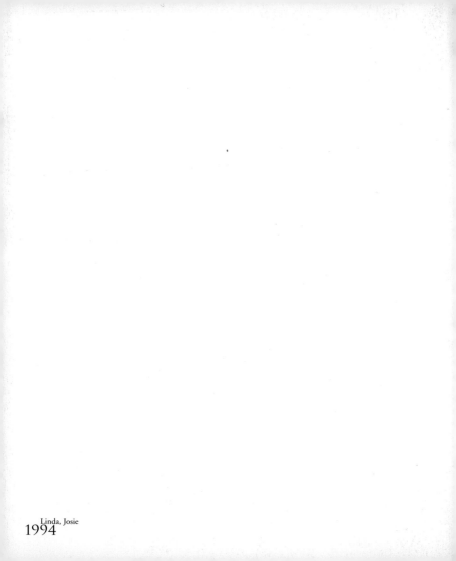

Linda, Josie
1994

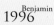
Benjamin
1996

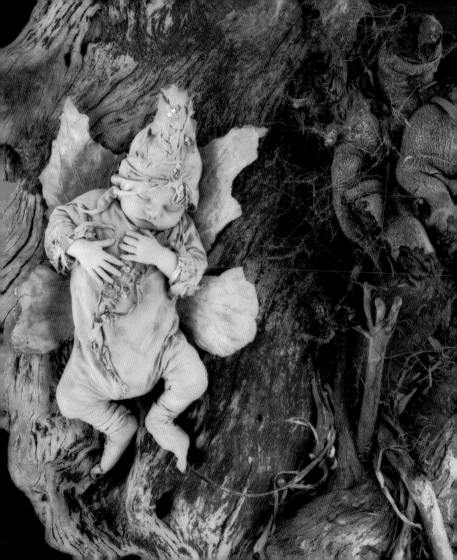

Neil, Tommy
1991

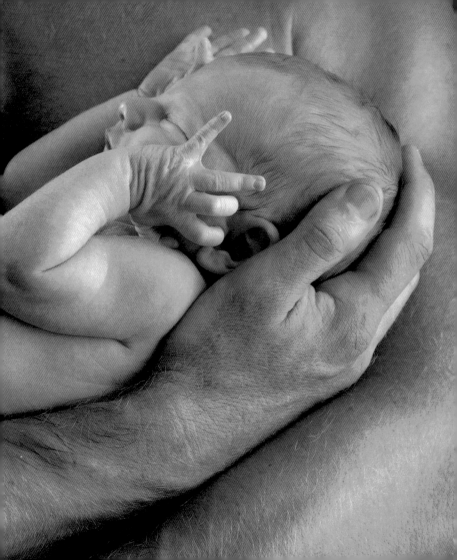

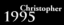
Christopher
1995

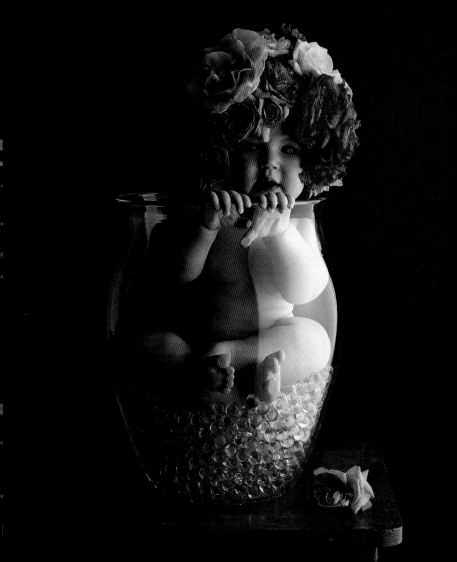

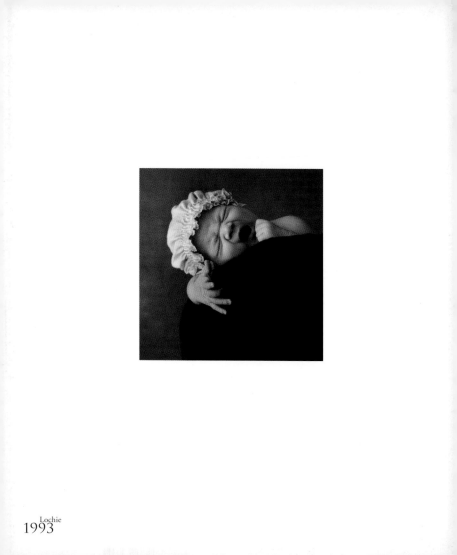

Lochie
1993

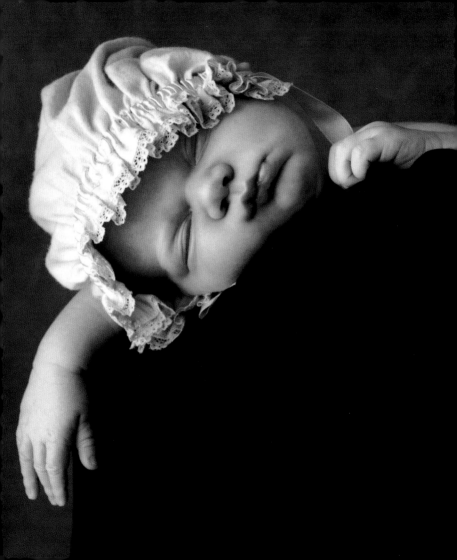

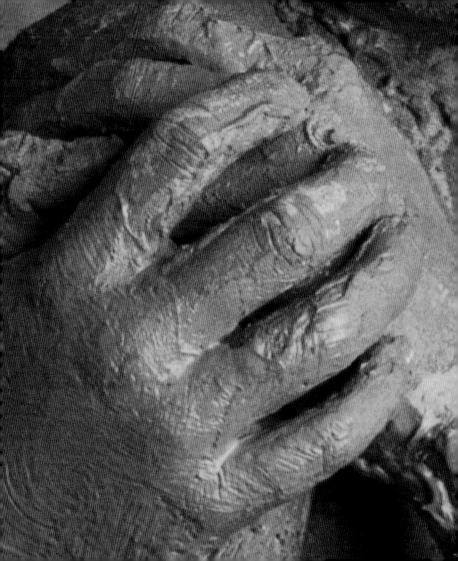

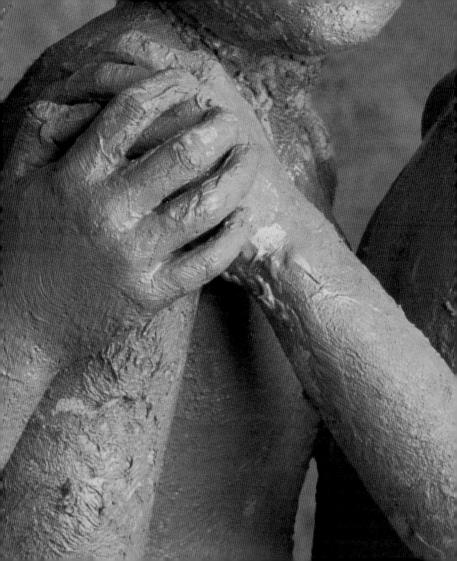

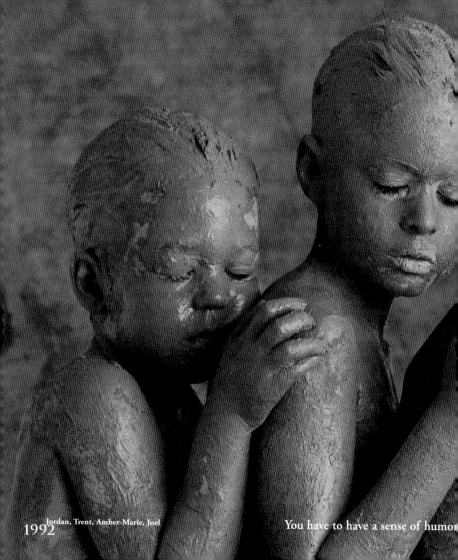

Jordan, Trent, Amber-Marie, Joel
1992

You have to have a sense of humor

keep an open mind, be a free spirit and relax. Photography is meant to be enjoyed.

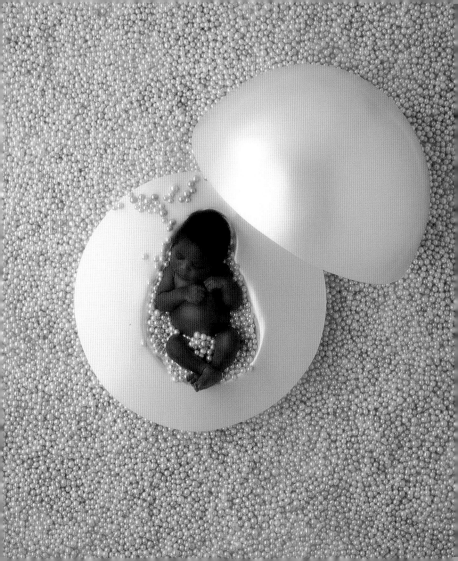

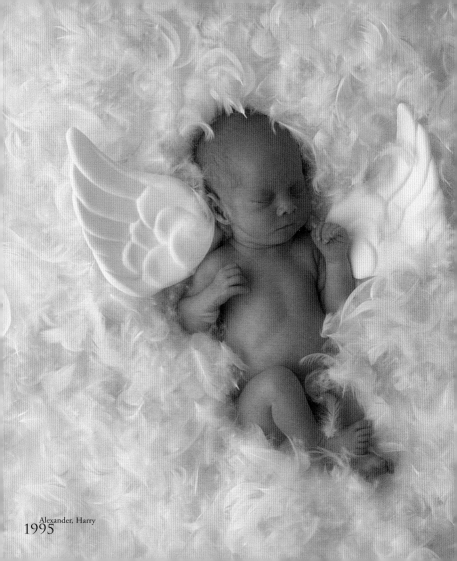

Alexander, Harry
1995

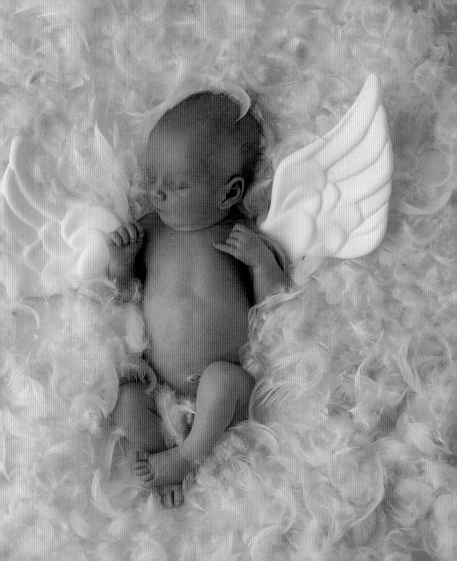

Elise
1995

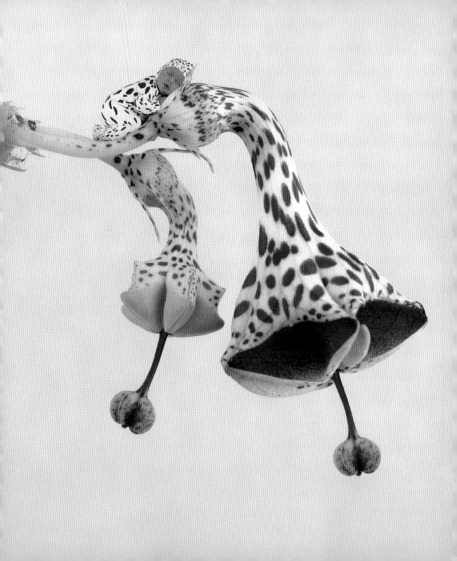

Antonie
1995

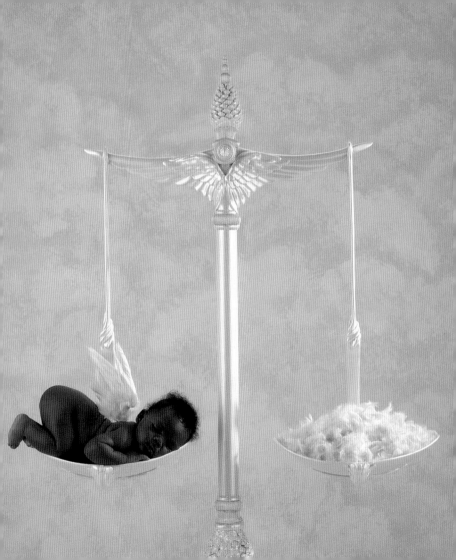

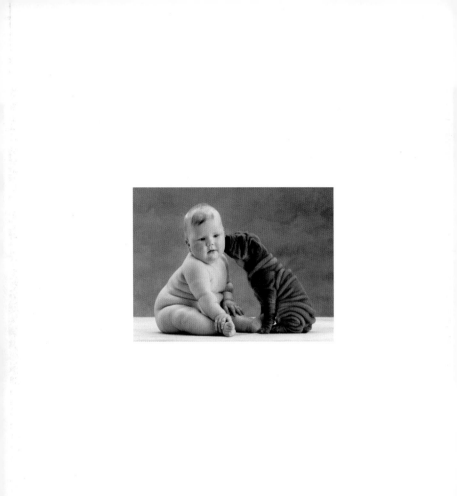

Mark
1994

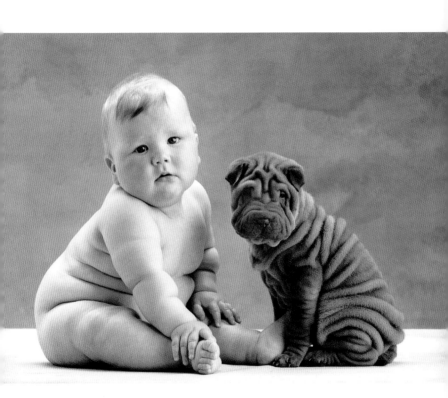

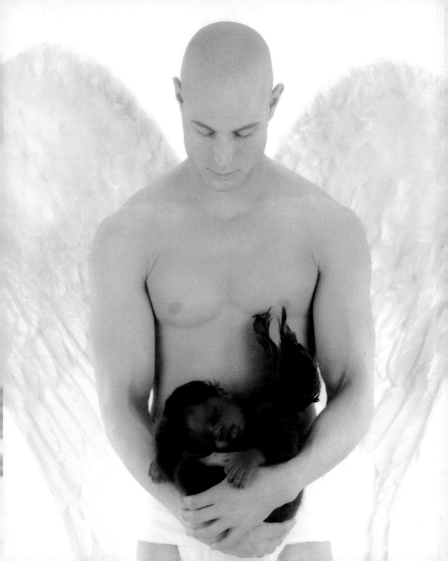

Jacob, Khaleah
1996

Tony, Annabelle
1996

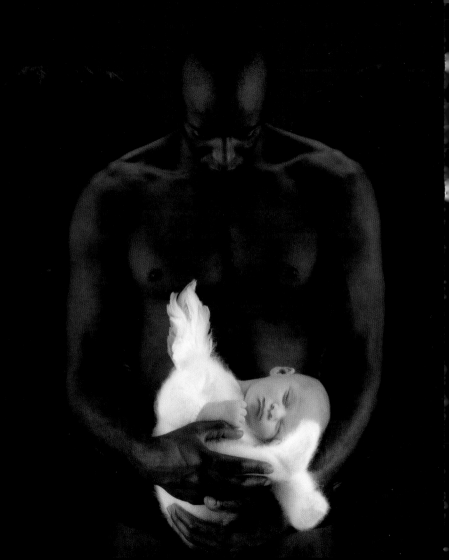

Alexus, Armani
1995

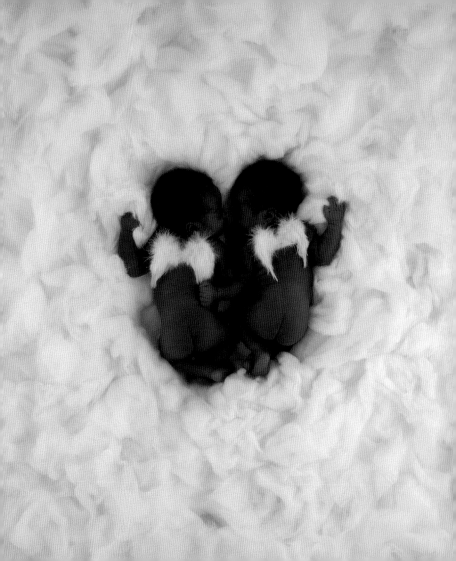

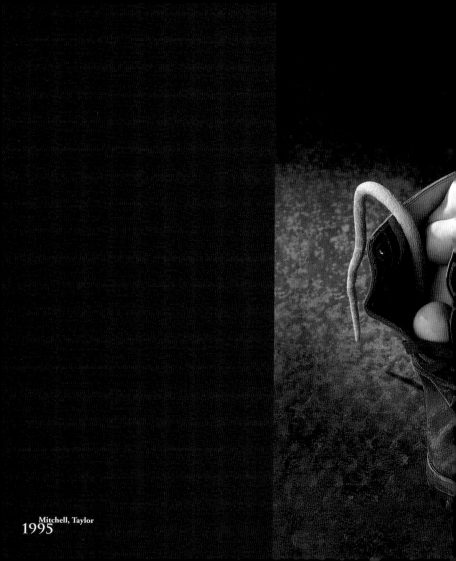

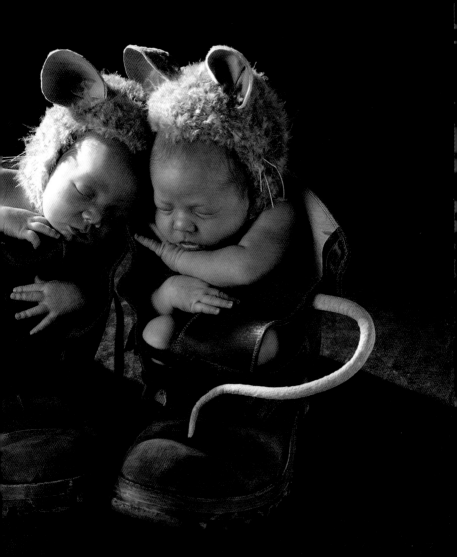

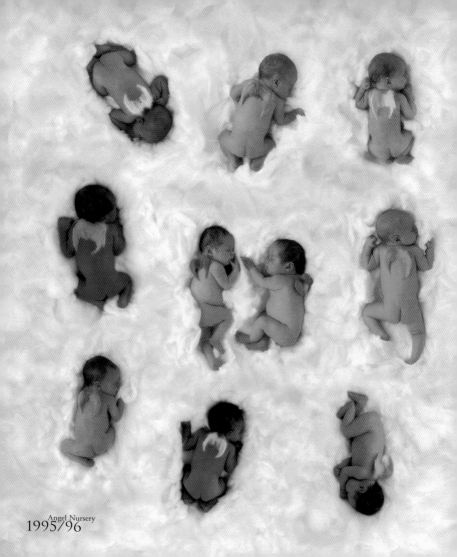

Angel Nursery
1995/96

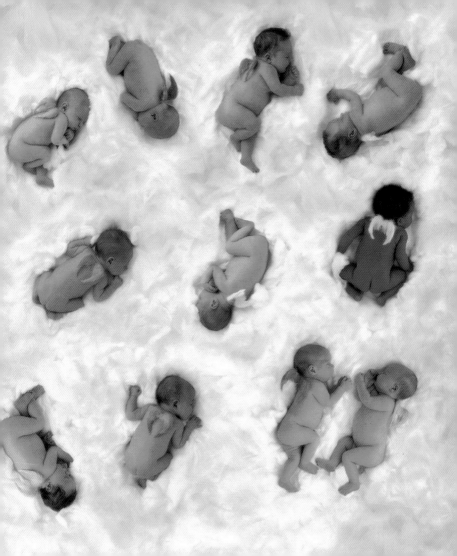

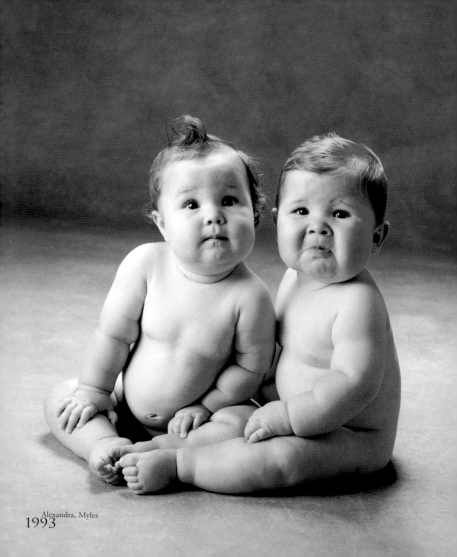

Alexandra, Myles
1993

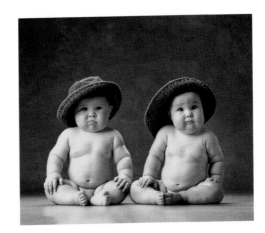

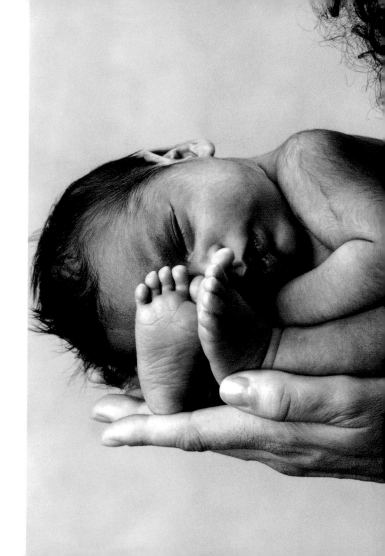

Barbara,
Maynard
1994

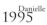
1995

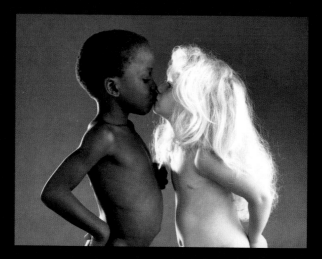

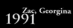
Zac, Georgina
1991

Ebenezer, Adnan
1992

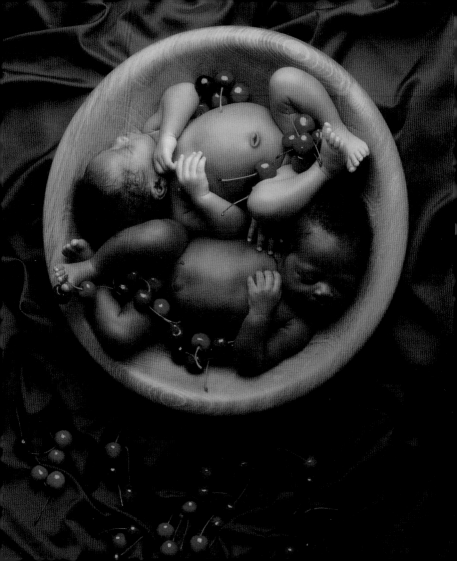

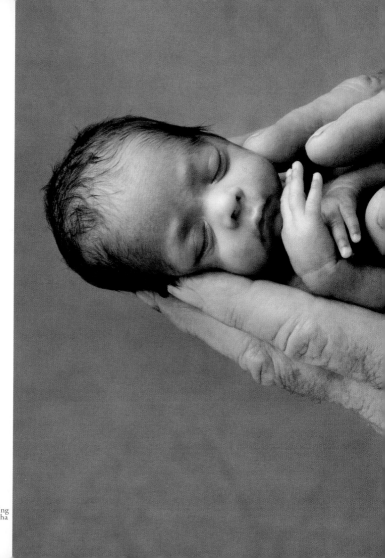

Jack holding
Maneesha
1993

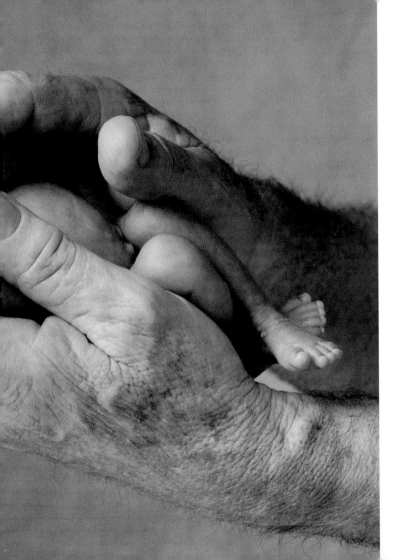

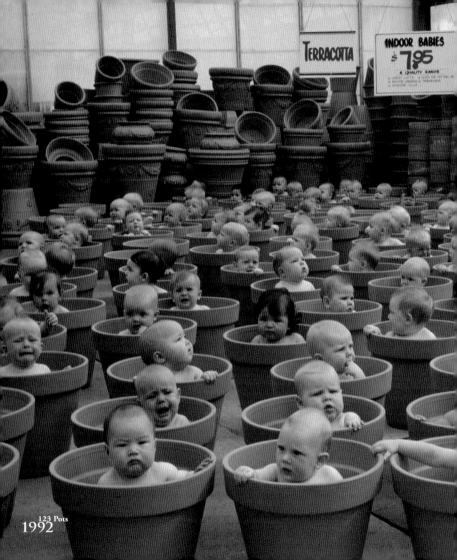

TERRACOTTA

INDOOR BABIES
$7.95
A QUALITY RANGE

123 Pots
1992

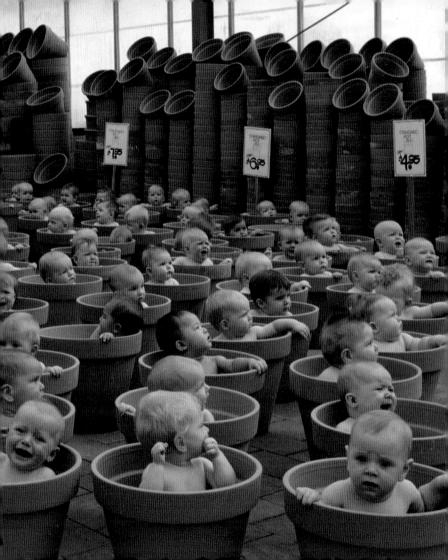

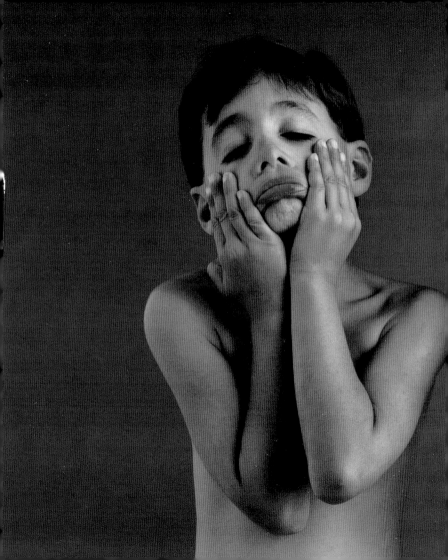

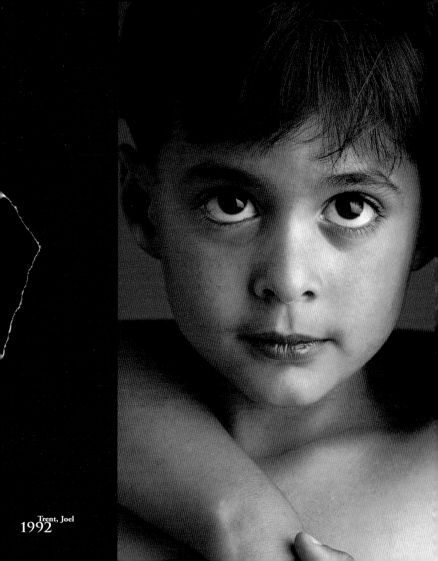

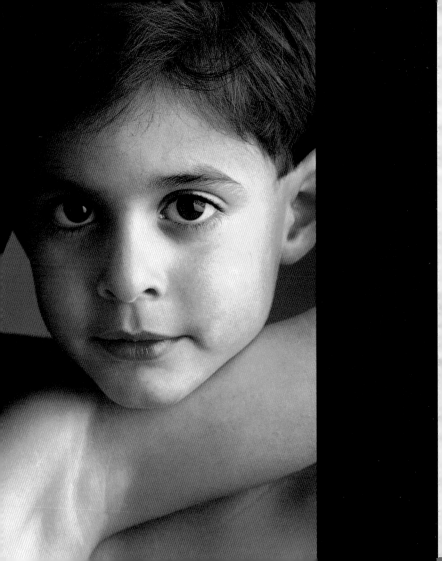

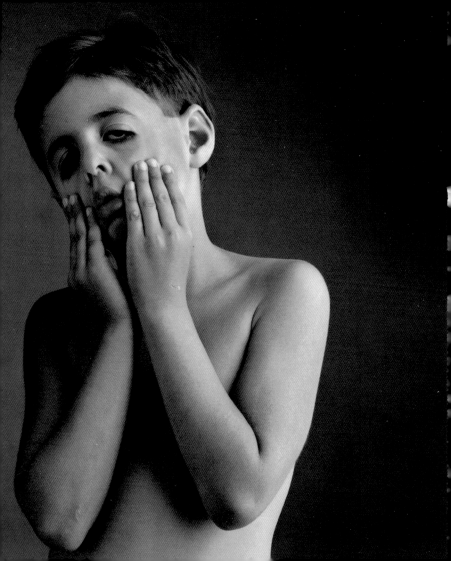

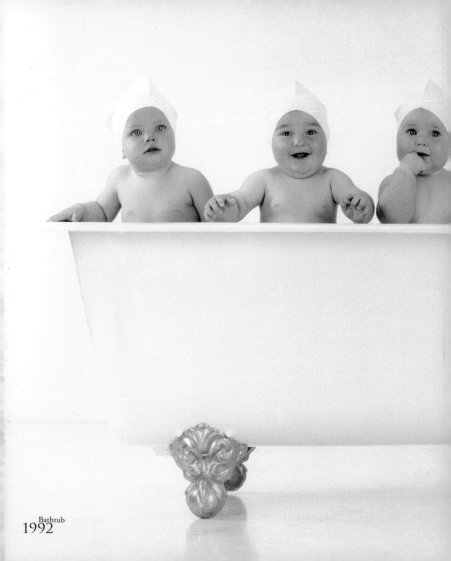

Bathtub
1992

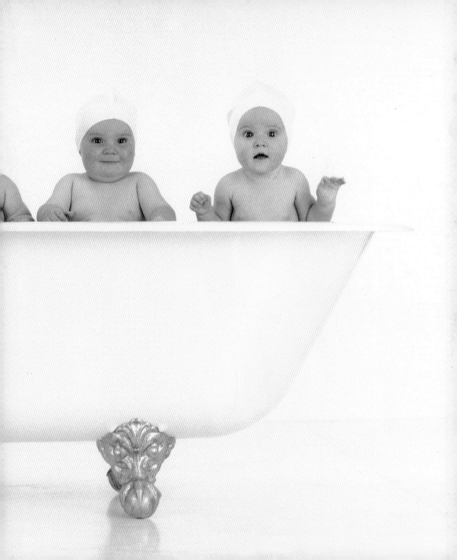

Aleesha, Jessie
1992

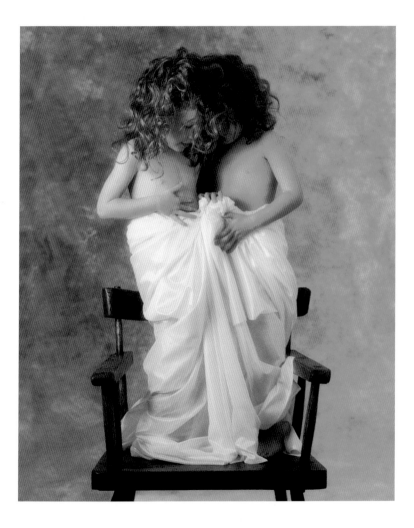

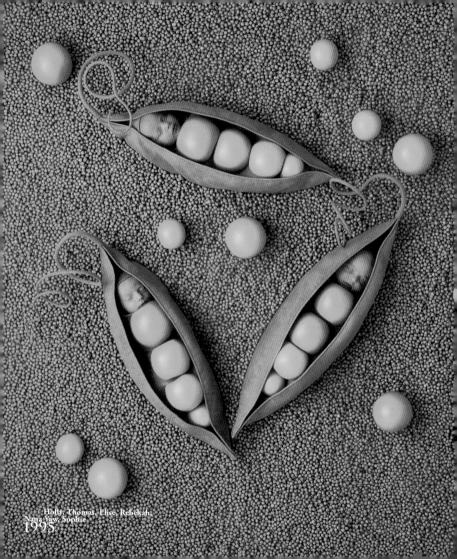

Holly, Thomas, Elise, Rebekah,
Nana-Yaw, Sophie
1995

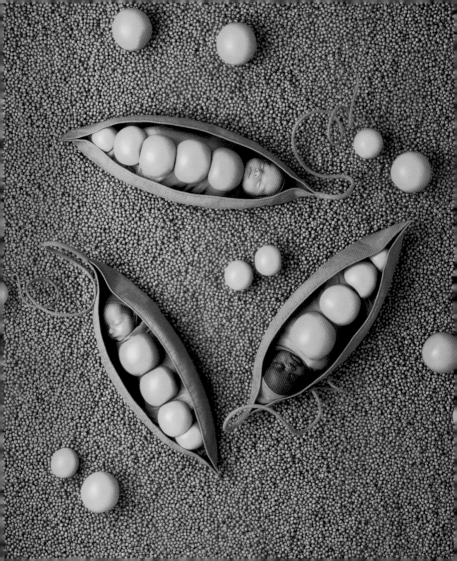

Cara, Danielle
1995

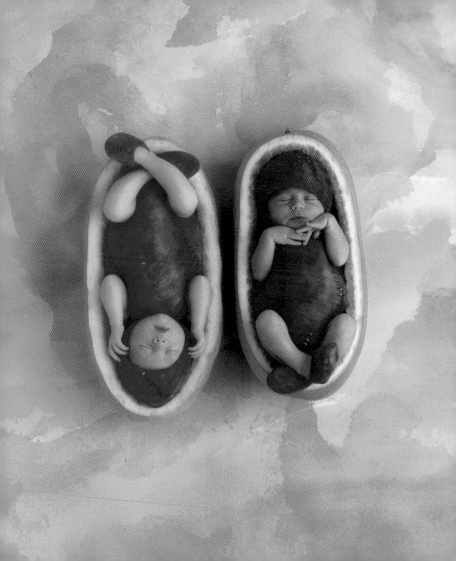

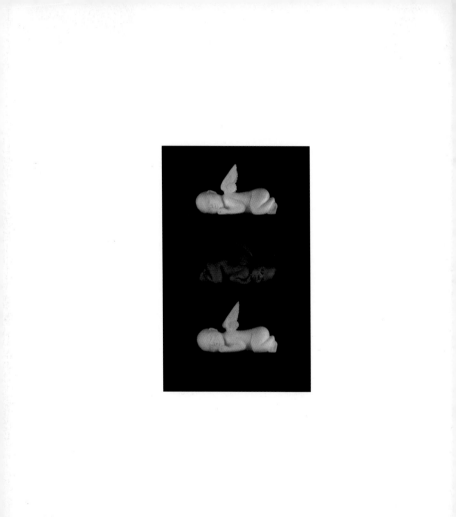

John
1996

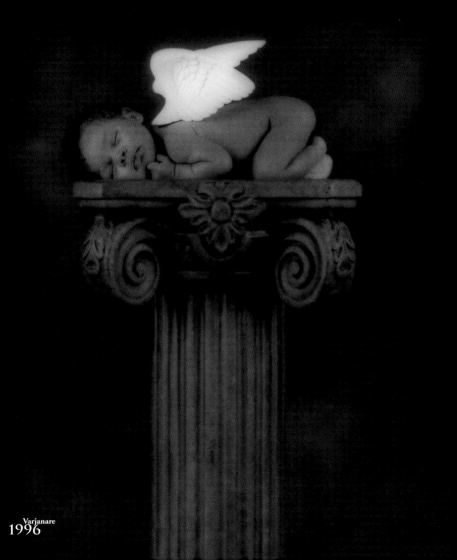

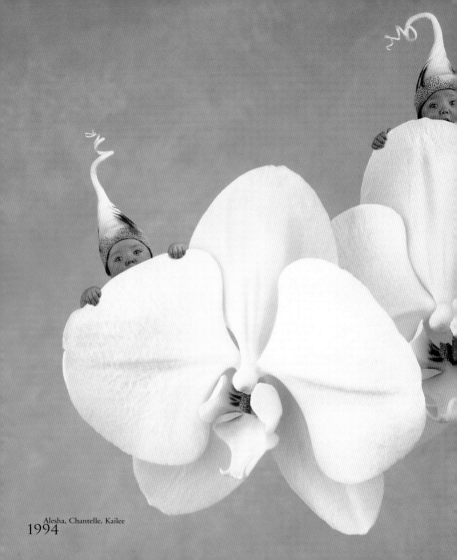

Alesha, Chantelle, Kailee
1994

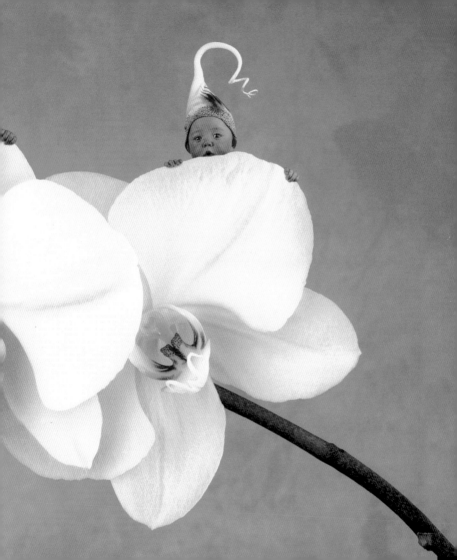

Tony, Kirsten
1993

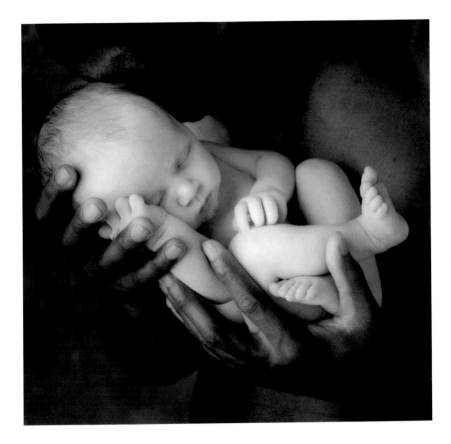

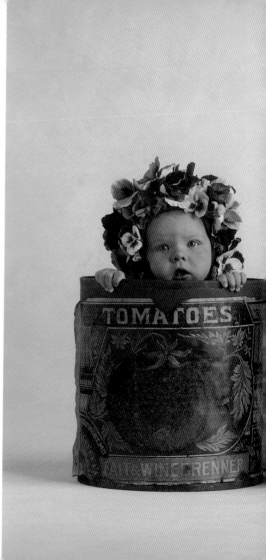

Aisha, Tayla, Grace
1995

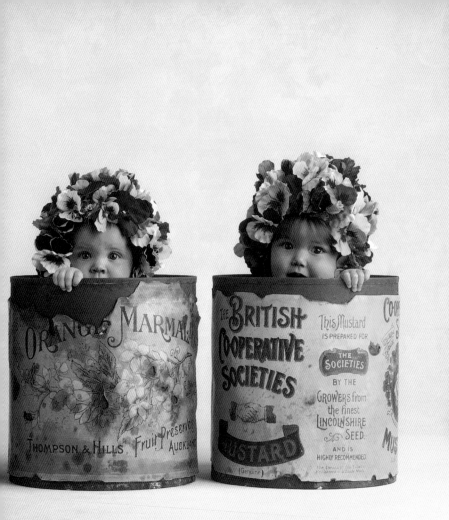

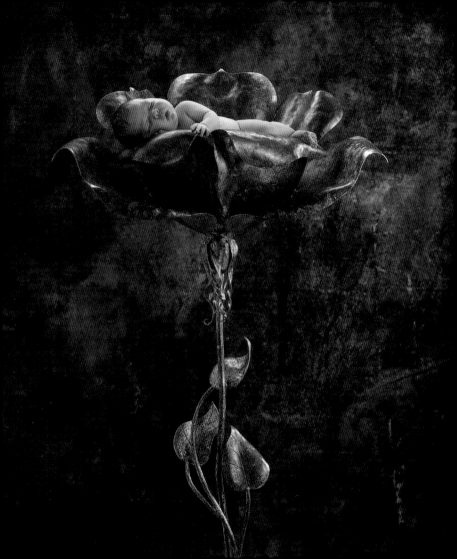

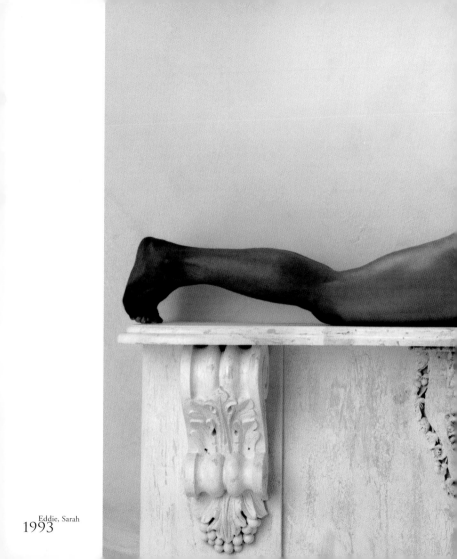

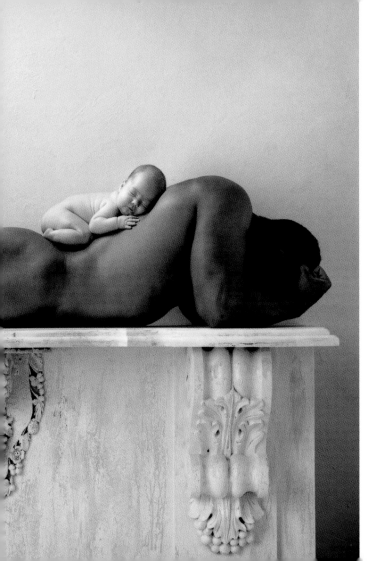

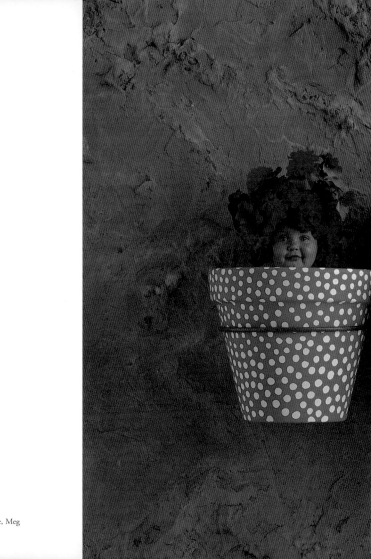

Olivia, Justine, Meg
1993

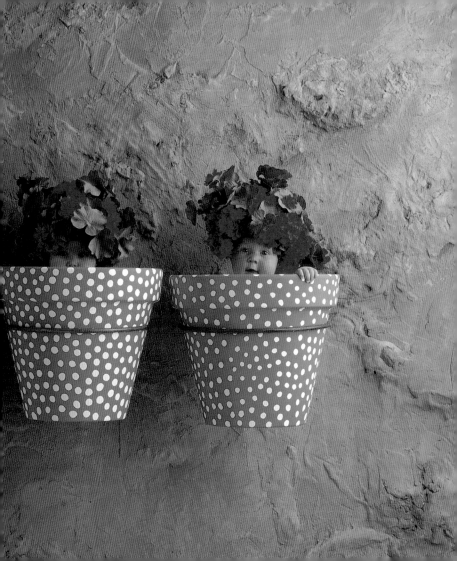

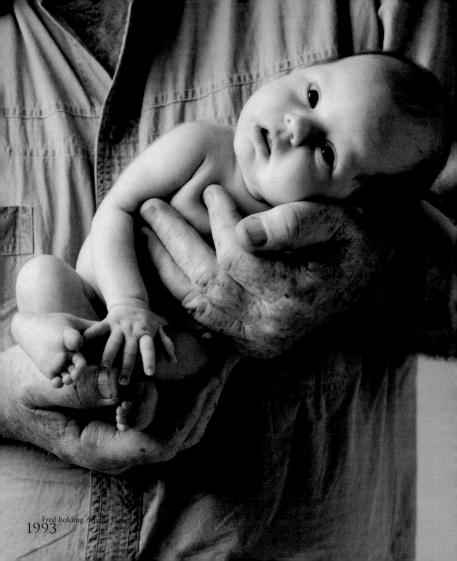

Fred holding Amelia Rose
1993

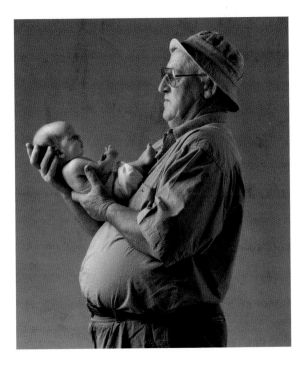

Laurence, Sharai
1991

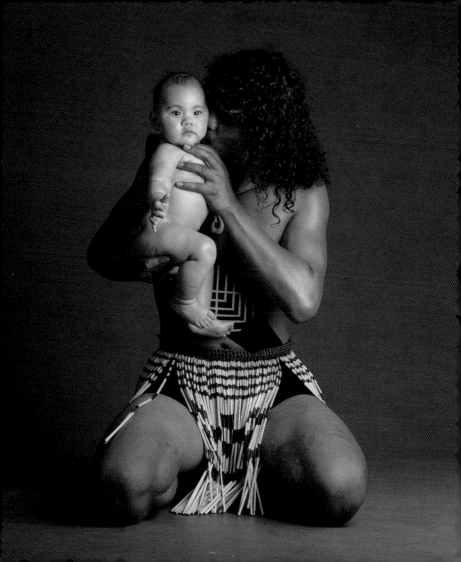

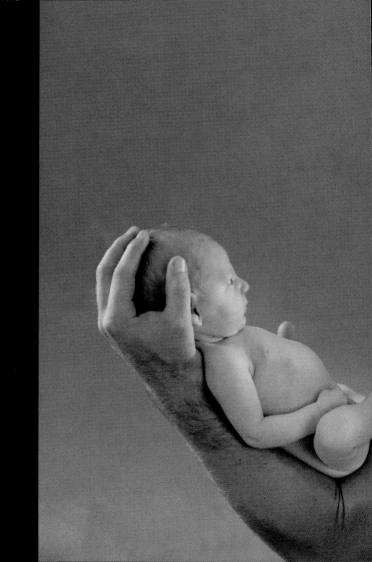

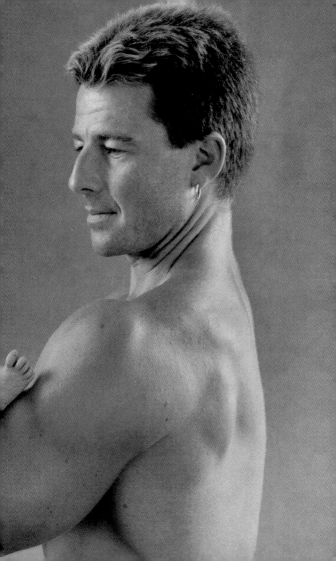

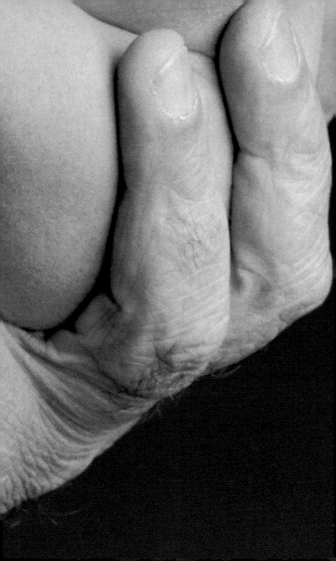

The hardest thing in photography is to create a simple image.

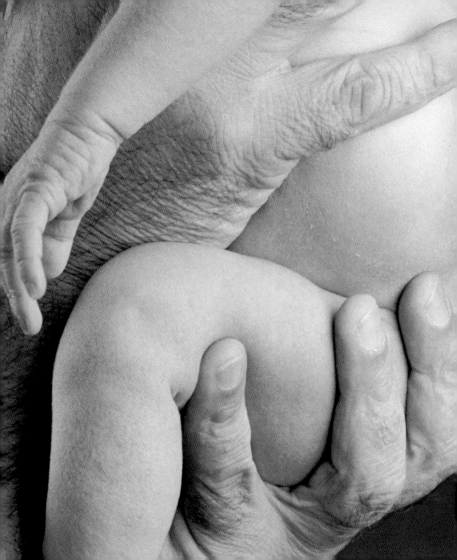

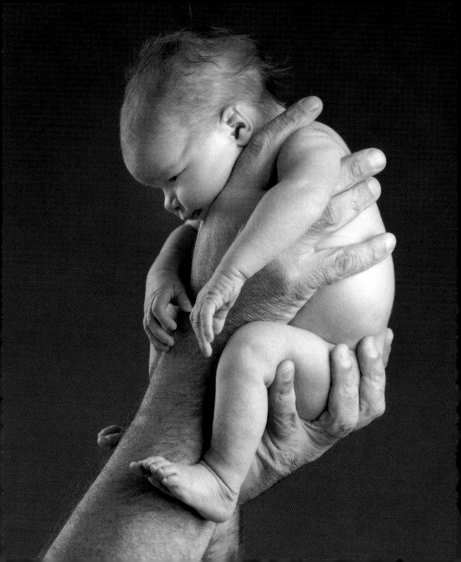

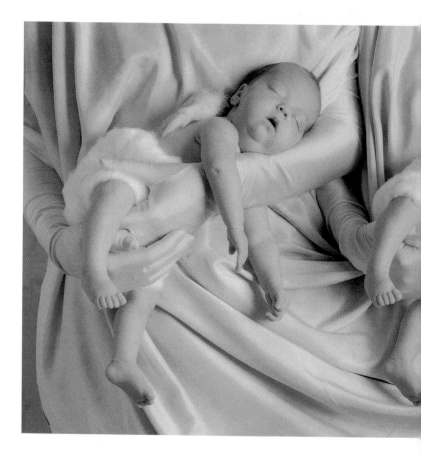

Tayla, Ash, Luka, Niko
1996

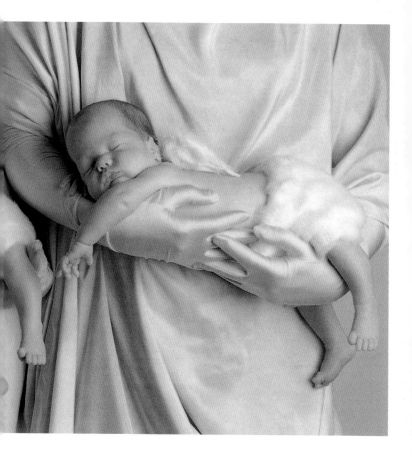

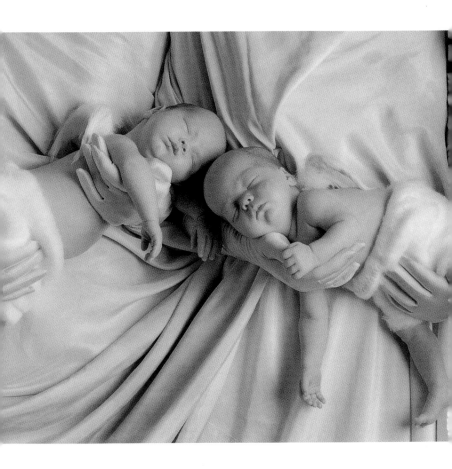

Sarah
1990

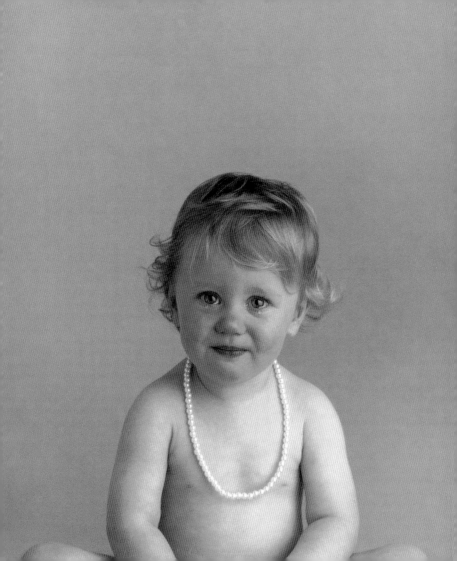

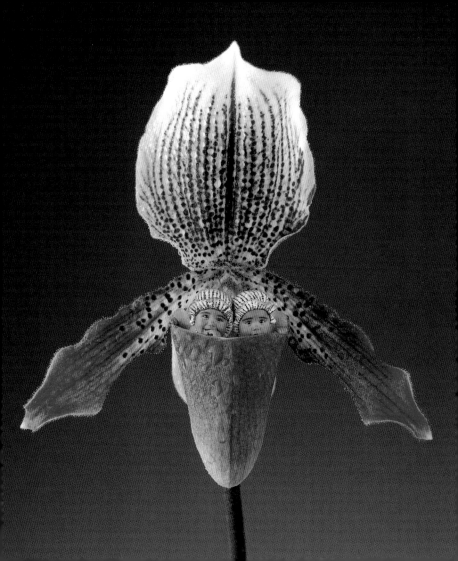

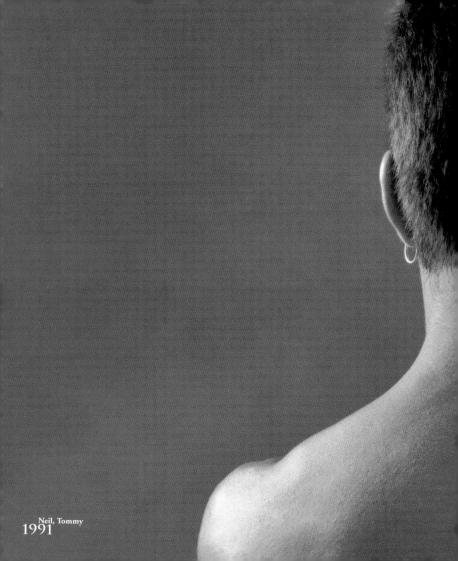

Neil, Tommy
1991

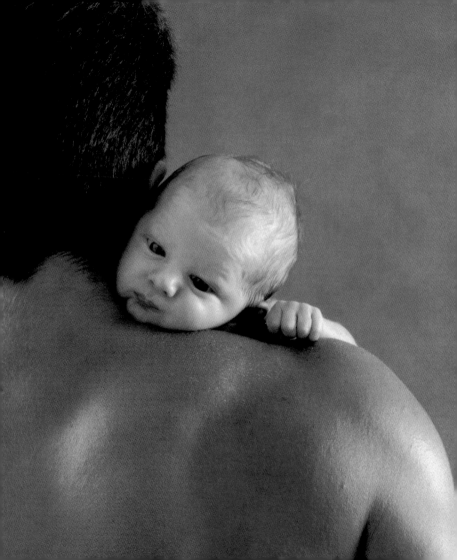

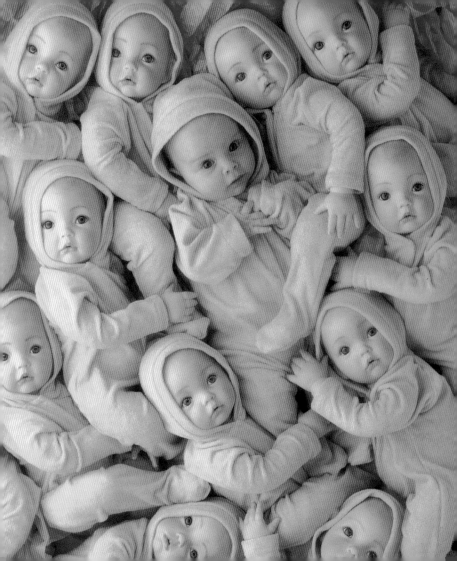

Olivia
1993

*Olivia's photograph
is dedicated to her parents, Clare and Garth,
her brothers, Jamie and Sam,
and her new little sister, Milly.*

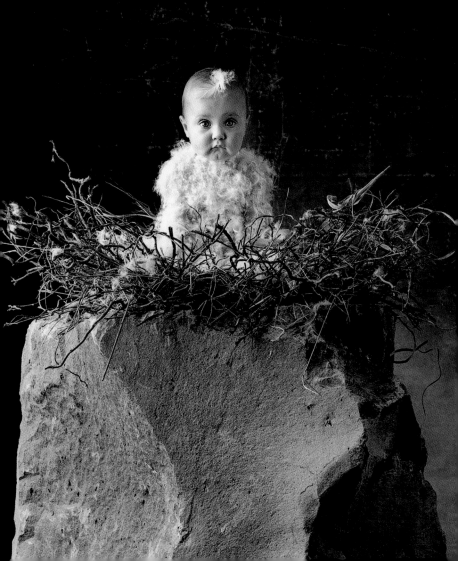

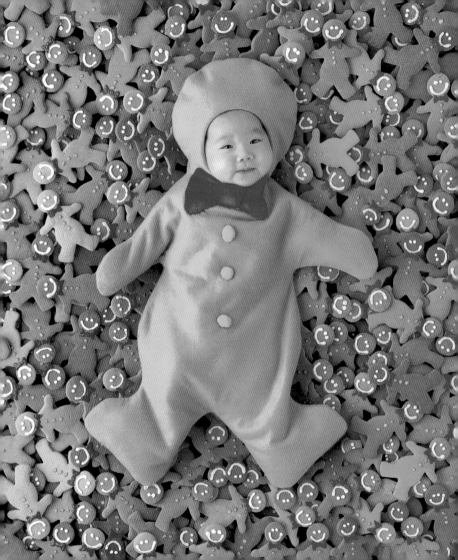

Alexander
1995

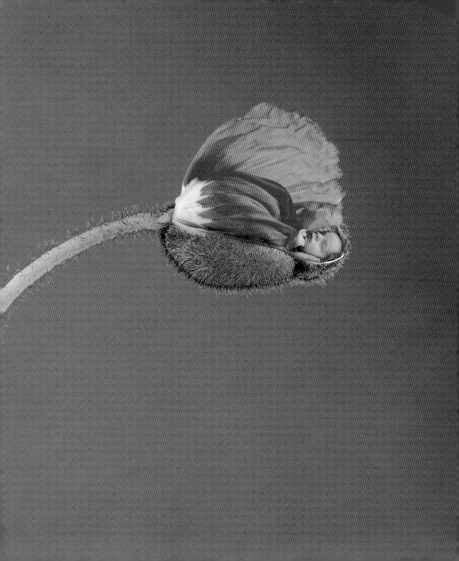

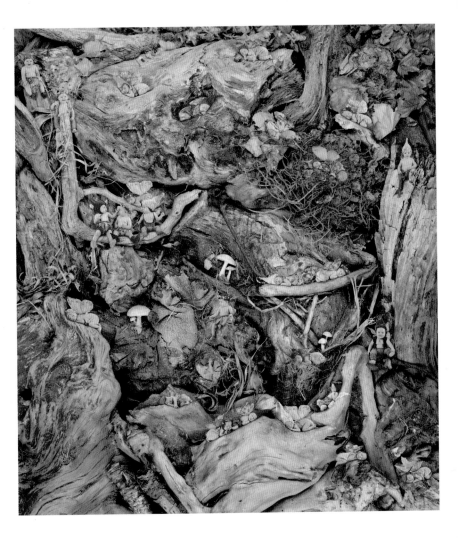

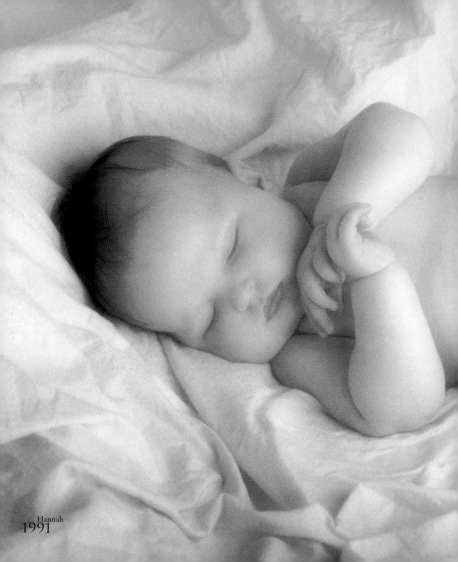

Hannah
1991

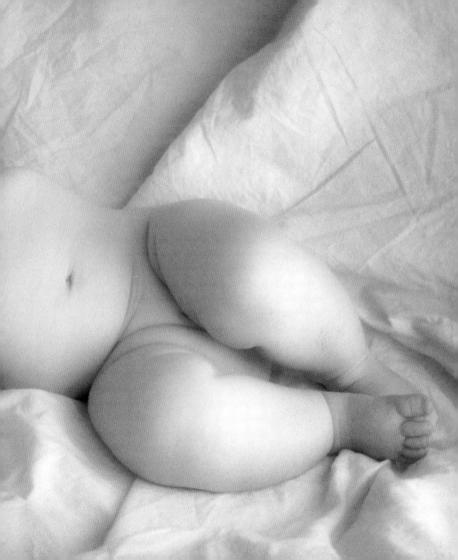

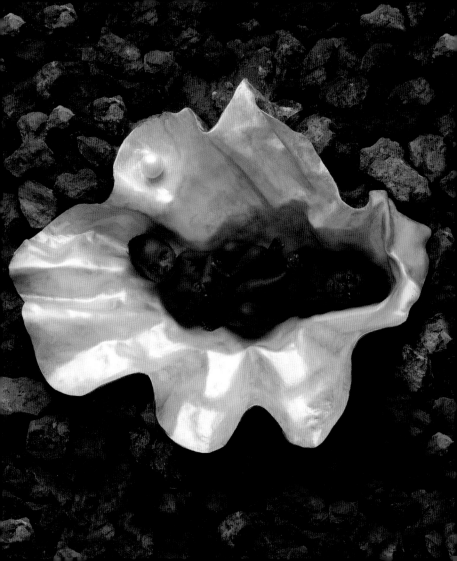

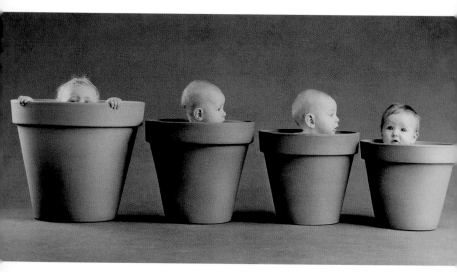

Stuart, Tessa, Thomas, Johnathon
1991

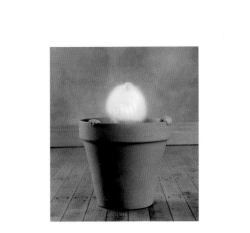

Tayla
1995

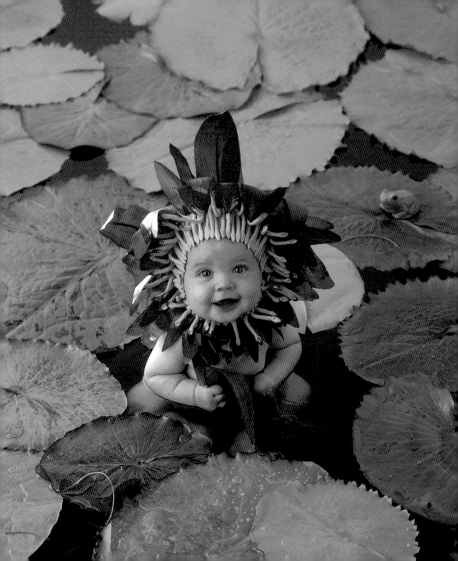

Linda holding Ben
1994

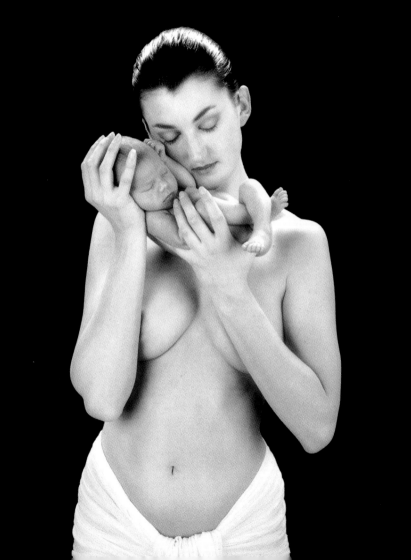

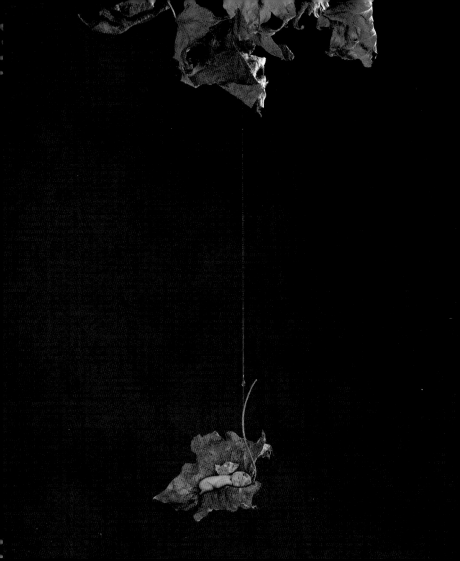

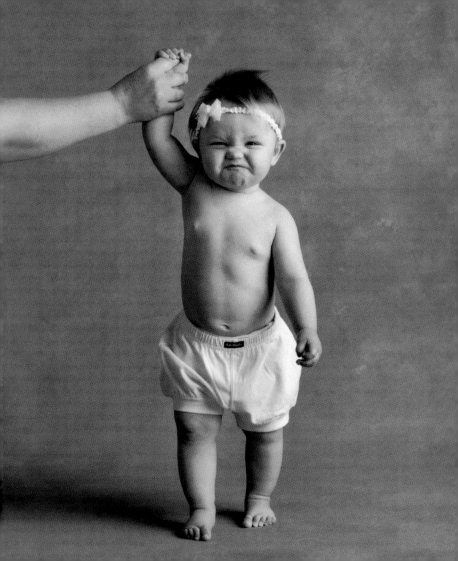

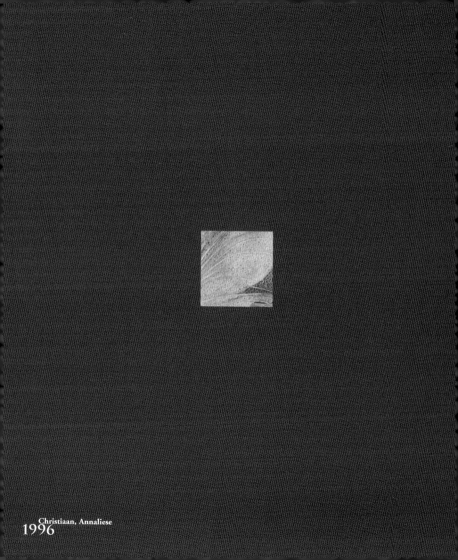

Christiaan, Annaliese
1996

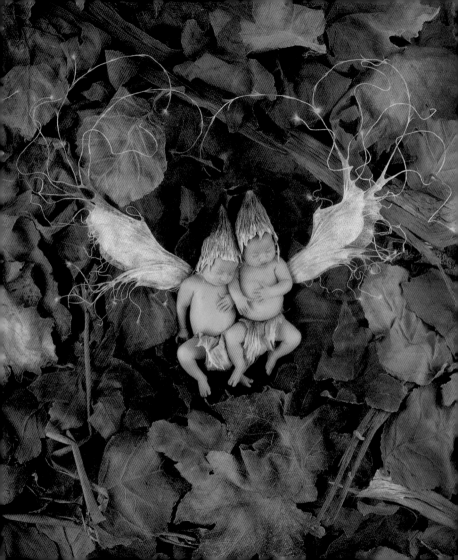

1995 ^{Fiona}

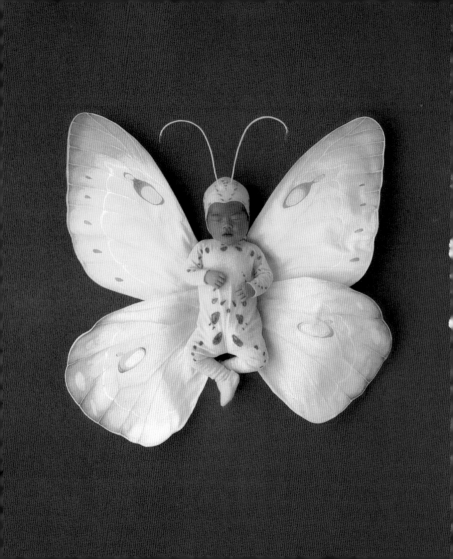

Matthew, Antoine, Dominique, Jabari,
Gabriel, Gabriella, Dionte
1993

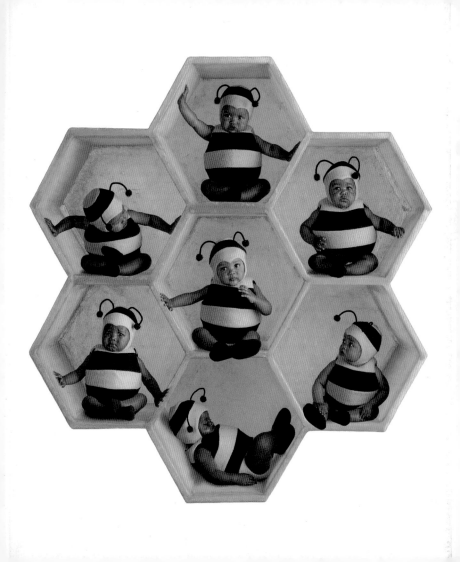

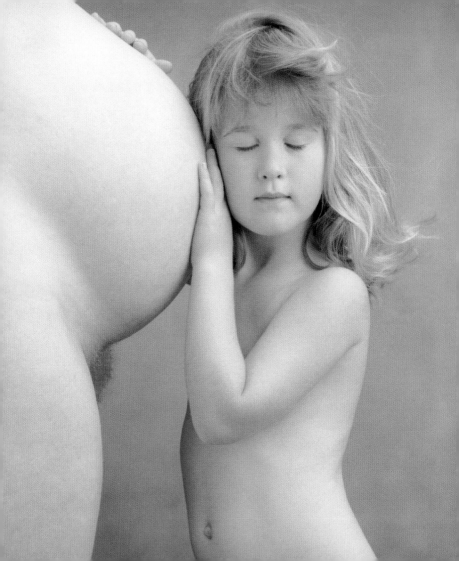

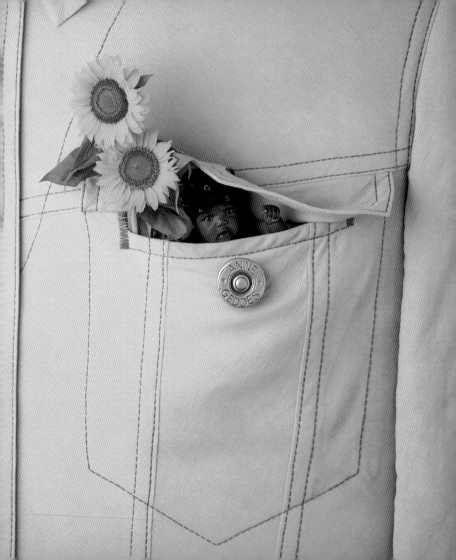

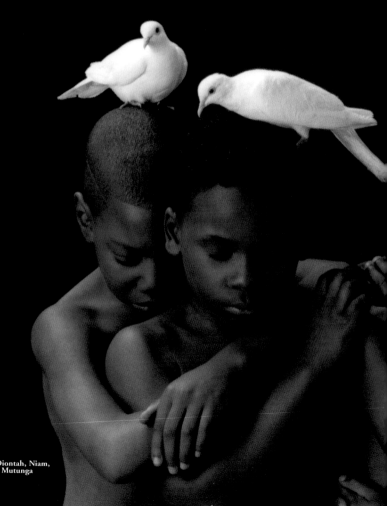

James, Diontah, Niam,
Greg, Mutunga
1993

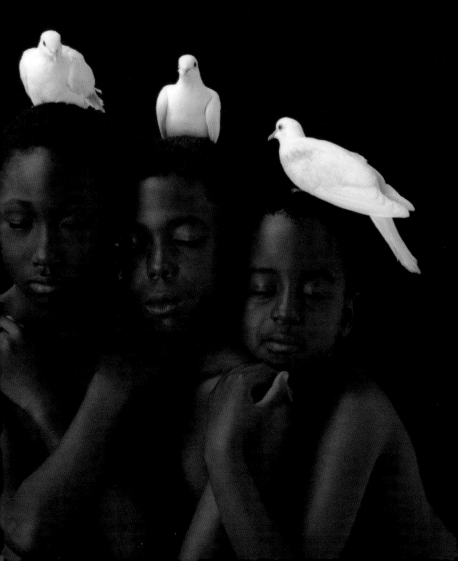

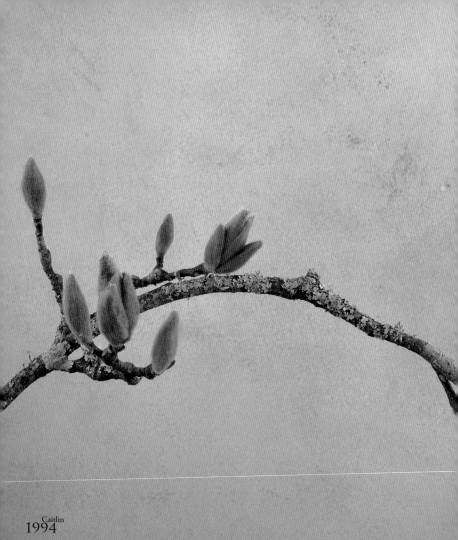

Caitlin
1994

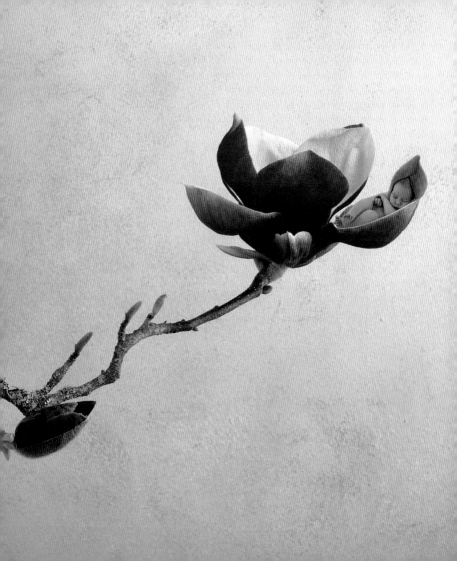

Erin
1994

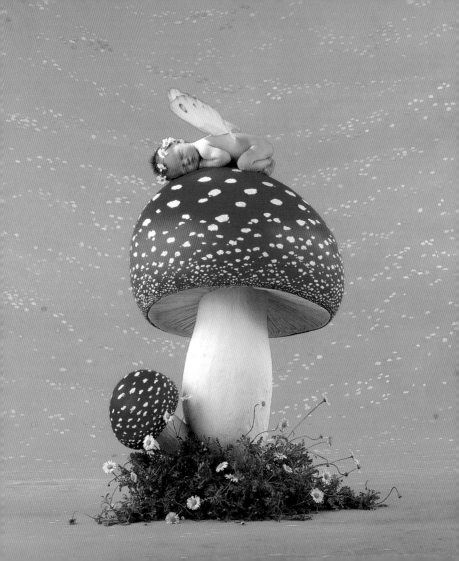

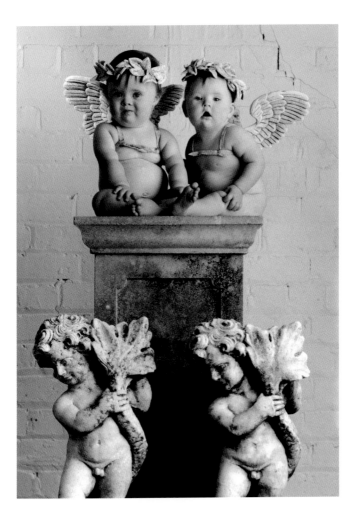

Milly, Natalie
1993

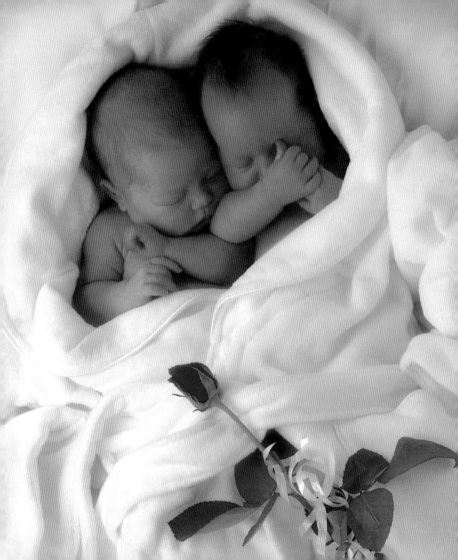

Jim, Flora, Pearl
1994

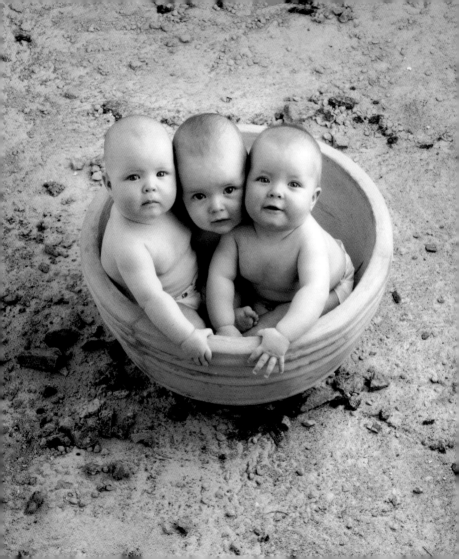

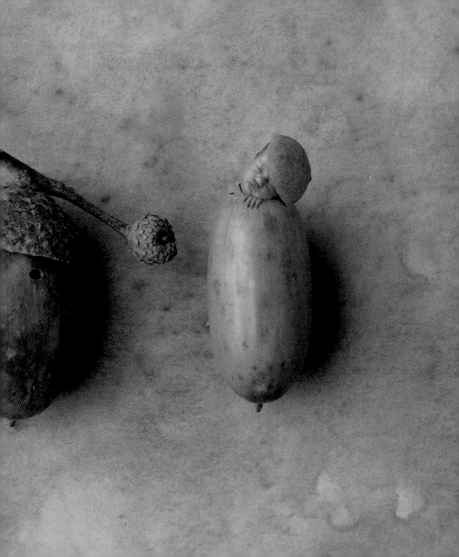

TONY HOLDING GEORGIA
Georgia (5 days)
1997

Georgia was only 5 days old, and had already been in for a shoot prior to this. I am always fascinated by the fact that newborn babies are so very flexible. This probably comes from living in such cramped quarters for the previous nine months! Tony, who is holding Georgia, plays in a basketball team in Auckland. There is only a very small African American population living in Auckland, or New Zealand for that matter, and I use Tony regularly. He has beautiful hands – and a personality to match.

GOLD FRAME
Ella, Michael, Carlin, Rayne, Sidena, Quilaine, Mitchell, Riley, Trent, Brooke, Connor, Cage, Caitlin, Phoebe, Scott, Dean (newborn and 6–7 months)
1997

There are 16 baby fairies incorporated into this frame. Each was photographed individually over a two day period, in beautiful fairy costumes which were made especially for this shoot. I have a lovely story to tell about something which happened on this day. Trent, who was 9 days old at the time, was just about to be photographed and his mother, Sonia, was standing behind me. As I stepped behind the camera, I heard her say to herself, "Oh, look at my son, isn't he beautiful." I turned around to see that she had a tear in her eye. Yes, indeed, he was very beautiful. All babies are beautiful, and this sort of story makes everything I am doing worthwhile.

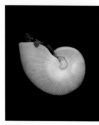

KOFI
Kofi (11 days)
1997

I thought I'd have to carry this prop shell all the way to a shoot in the States, as it is very rare to find an African American baby in New Zealand, and then I was lucky enough to find Kofi, who was born in Auckland. The idea for the shoot came whilst I was holidaying in North Queensland, in Australia, which is the home of the Great Barrier Reef. I love the amazing shells up there. Mother Nature never seems to get confused about color or design, but she certainly never made a shell this large.

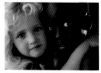

ZAC & GEORGINA
Georgina (3 years), Zac (4 1/2 years)
1991

Zac was originally from Haiti, and has been adopted into a Canadian New Zealand family. He has a brother who is Korean, and another who is a Canadian-born New Zealander. They are truly a "United Nations" family. Georgina was the perfect complement to

him – she had such gorgeous fair hair, and lovely pale skin. The two of them had a great time doing the shoot.

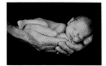

JACK HOLDING ARIANA
Ariana (25 days premature)
1997

This is the second time I have used Jack's hands in one of my images, the first time being when he held the little premature baby Maneesha. Jack is really the original "gentle giant," and he has huge hands. Ariana was on an "early release" program from hospital – she had been born 25 days early, and weighed just under 2.3 kg.

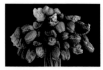

POPPIES
Mariana (6 weeks), Christopher (1 week)
1995

Poppies are my favorite flowers. I had photographed this bunch a few years earlier, but didn't have anywhere to use it until the *Down in the Garden* book concept came along. The two little ladybugs were photographed in San Francisco in 1995.

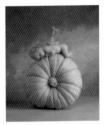

COUNTRY PUMPKIN
Amelia Rose (9 weeks)
1993

There was a giant pumpkin competition at a local fair, which is where we met Rhys, who not only grows giant pumpkins, but giant sunflowers, beans, you name it. This is not his winning pumpkin. That particular one wouldn't even fit through the studio doors! The pumpkin pictured here took three people to carry it. It isn't easy getting a baby to sleep on a pumpkin, even though the top is a lot wider than is apparent in the image. When we finally got Amelia Rose up there I only got one shot because the flash woke her.

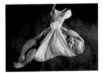

JOSHUA
Joshua (4 months)
1990

The Plunket Society in New Zealand used to weigh newborn babies in cloth diapers, so this is where the idea for this shot came from. Over the years, it's been interesting listening to other people's theories as to why the hook is there. No reason at all,

other than it was the most logical choice to me. I recall that it was a very hot day when this image was done, and I was cradling Joshua to sleep (already in position in his sling) while standing on a rebounder under the fan. Every time he felt his own body weight, as I gently released him, he would wake up, and we'd have to start all over again. He was just fine, but everyone else was exhausted! Then he finally went into a deep sleep, and we all had a well-earned coffee break, while he dozed away there, slowly rotating.

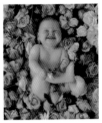

CHEESECAKE
Phillipa (8 months)
1992

"Cheesecake" is one of my favorite images. This was originally done as a portrait sitting, and Phillipa's mother had a beautiful rose garden. She arrived with buckets full of roses, all de-thorned, and one baby, who was sitting on the floor in reception when I walked in to say hello to her. She looked up at me with this beautiful smile, and her mother said that if you smiled at her that way, she would copy you. I wish we had a video of me and my assistant, up on a ledge near the ceiling, looking down on her lying in her bed of roses, and trying to get her to smile like that again – and then she did.

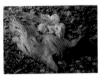

WOODLAND FAIRY
Sophie (5 weeks)
1995

Every time I look at this image, I think of Sophie's lovely head of black curly hair – which nobody gets to see! That solid piece of driftwood was spotted by my friend Neil, who was my black and white printer, on a beach at the bottom of a 20-meter cliff in a suburb of Auckland, and was carried to the top by four men, who by the time they got there clearly had doubts as to its artistic merits!

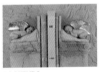

BOOKENDS
Sarah, Craig (7 weeks)
1996

Getting twins to sleep at the same time is so much harder than getting one baby to sleep. You get one asleep, then the other, then the first one wakes up. It's a nightmare – as any parent of newborn twins could certainly vouch for. At least I'm not trying to get them both asleep at three o'clock in the morning, although I did have the added complication of getting the gold wings on!

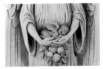

JONTI AS AN ANGEL
Jonti (14 days)
1996

Jonti had been in for a shoot prior to this, and I thought she was just so lovely, and so tiny, that she was the obvious choice for this image. When we put her in the hands of the angel, she just seemed to melt into the spot and then lie there so comfortably with her little mouth open. The angel itself was very light and had been especially carved out of one huge block of foam. It is always difficult to find ready-made props to accommodate the special needs of babies, and therefore we take a great deal of time and trouble to make suitable, safe and comfortable props for the individual shoots. My dilemma is always what to do with them all afterwards.

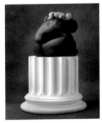

PHILLIP & ARIN
Arin (4 weeks)
1993

We were in San Francisco on a shoot and had a spare afternoon, so I sent my assistants out to find a bodybuilder. They were waiting

in the parking lot of a local gym when Phillip came out. He must have thought they were crazy, but he still came along. I asked him at the shoot what he would do if he felt the inevitable trickle down his back, and he said he'd be fine. People who have never had much to do with young babies always need to be forewarned! True to form, halfway through the shoot, poor Phillip said, "Oh my goodness..."

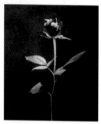

APHIDS
Callum (8 days), Sam (5 weeks)
1994

I love flowers, but always other people's flowers, as I am definitely not a gardener. People who know me were quite amused when *Down in the Garden* was published and became so successful. This image is from that book. If you think they're aphids on your roses, look closer.

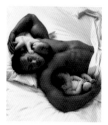

EDDIE WITH SCOTT & SEAN
Scott, Sean (5 weeks)
1993

Eddie has done quite a lot of modeling for me. He is also a personal trainer. I always like to use models who are comfortable and relaxed with young babies, because if everyone is tense in a shoot, the babies will pick up on it.

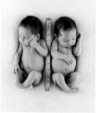

REBECCA & COURTNEY
Rebecca, Courtney
(25 days premature)
1997

Rebecca and Courtney were premature twins who weighed 2 kg each. They were just out of hospital on an "early release" program. Although they were very tiny, they were healthy enough to go home. They were like two little dolls. Just recently, their mother sent us a photograph of them at 6 months – big, chubby, healthy, beautiful babies!

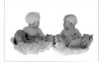

CABBAGE KIDS
Rhys, Grant (7 months)
1991

Apart from making these two cabbages out of 20 others, the hardest thing about this shoot was getting twins Rhys and Grant to look at each other, and not at everything that was going on in the studio. We had a balloon on a piece of string, which my assistant lowered from the top of the shot, down between their heads. As soon as they looked at the balloon, she pulled it up quickly. Part of the charm of this image to me is that they really have no idea that they have cabbage leaves on their heads.

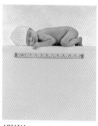

ARIANA
Ariana (25 days premature)
1997

Those of us who are parents often seem to forget how tiny our newborn babies were. Here is Ariana again. She is the same baby who is in Jack's hands in an earlier image. When I saw my first print from this shoot, I thought how wonderful it would be for her to have this image to look back on when she had grown up.

MILLY OLIVIA ROSE
Milly Olivia Rose (3 weeks)
1997

Milly is a very precious baby. She is the little sister of Olivia, who is also in this book as my "Baby Bald Eagle." Olivia's story is told with her own image, later on.

SLEEPING LION
Scott (3 weeks)
1993

My daughter, who was 6 years old at the time, was reading a wonderful book about an emu who wanted to be any animal other than an emu. I can understand this. There was a lovely illustration in the book of the emu lying along the branch of a tree, pretending to be a lion, and this is where the idea for this image came from.

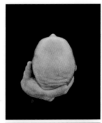

CALEB
Caleb (3 weeks)
1997

The top of the head of a newborn baby is very soft and delicate. Most newborns love their heads to be stroked. This is Caleb, who was 3 weeks old, with his dad, Gary.

Below is Caleb on his own. Both of these images are from the same shoot. Caleb's two older brothers, Levi and Lochie, also posed for me when they were babies. Lochie features later in the book. They were all just the way I love babies – big, beautiful and bald!

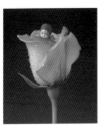

ROSE
India (5 months)
1992

India was a premature baby, and premature babies have the most beautiful big eyes. It's almost as if they have to grow into them. As soon as I saw India, I knew she would fit perfectly into the rose.

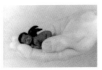

C.J.
C.J. (6 weeks)
1996

This image was done in San Francisco. The hand was made in Auckland, and was enormous – we had to transport it over for the shoot. Can you imagine the American Customs Officers saying, "What's in the box?"

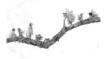

FAIRIES
Victoria, Shanna, Scarlett, Kate, Elizabeth, Eliza, Emily, Lilly
(newborn to 4½ years)
1995

Some of my fairies didn't want to put the costumes on, and some of them didn't want to take them off afterwards. Generally, the ones who didn't want to take them off afterwards were the same ones who didn't want to put them on in the first place. A couple also tried to fly.

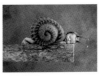

JULIA SNAIL
Julia (3 weeks)
1994

I was recently talking to Julia's father, and asked him if they had had any more babies. He said, "No, we stopped at the snail."

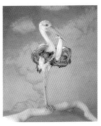

MOTHER STORK
Eden (16 days), Sarah (9 days)
1996

We christened the stork Susan. She was made from scratch over a period of four weeks, and really was a work of art. She looked so fabulous that I kept her in the studio for many months afterwards. She watched over everybody, impressed a lot of small children – not to mention adults – and reminded us all where babies really come from. We even dressed her up for Christmas, with presents under her wings. Then she started to go a funny shade of yellow from the glue in her feathers, so we sent her off to stork heaven.

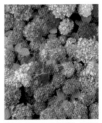

HYDRANGISS BABYISS – RARE BLOOM
Ruby (6 months)
1994

Hydrangeas always remind me of old ladies' church hats – with due respect to old ladies. There is a street in Auckland where, at a certain time of year, hydrangeas are everywhere. So I have to confess that we surreptitiously gathered hydrangeas from various gardens in an exciting raid one quiet January afternoon. I always imagined getting an irate telephone call from an avid gardener in that street, who upon seeing the image recognised a particular flower as theirs, from perhaps the only hydrangea plant of its kind in the country, and we would have been exposed! Ruby, the baby, had one of those "little old lady" faces, so we called it "Hydrangiss Babyiss – Rare Bloom," which she is.

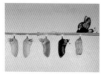

MONARCH BUTTERFLY
Danielle, Elijah, Nicholas, Tara, Thomas (newborns)
1995

I had swan plants in my garden, and monarch caterpillars love the leaves of the swan plant. Soon there were chrysalises everywhere, hanging off flowerpots and garden chairs. This was the inspiration for this image. The actual chrysalis prop was full of cotton wool, so the babies were very comfortable. In fact, most of them arrived at the studio asleep, posed in the chrysalis asleep, and went home asleep, not even knowing that they'd been there. Each chrysalis was attached to the branch by computer.

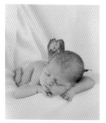

AIMEE AS A FAIRY
Aimee (7 days)
1997

Aimee was 7 days old, and in this image she is lying on my Studio Manager's lap. Natalie has a big wet patch on her jeans underneath the white cloth. I think she would be pleased to be acknowledged for this!

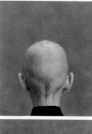

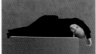

STACEY
Stacey (9 years)
1997

Stacey was my very special friend. She came into our lives when she was 6 years old, and for three wonderful years she gave us far more joy than we could ever have given back to her, although we tried. These two images were taken the day after the doctors told her that there was nothing more they could do for her, and that she possibly had only three weeks to live. We had already planned the photo session prior to this news, and I naturally thought she wouldn't want to go ahead with it. But she was adamant that she wanted to. I knew while we were doing the shoot that for her own reasons she wanted to make the images special. She died of cancer just after she had turned 9. Now she is a real angel.

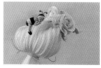

BABY BEE
Tyrone (2 weeks)
1995

Little bumblebees sleep inside pumpkin flowers at night, because they don't have their own homes. Rhys, who grew my giant pumpkin for the "Country Pumpkin" shot, told me this, so it must be true. They crawl in before the flowers close at sunset, and fly out in the morning. This particular image shows what happens when you break the curfew.

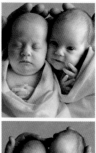

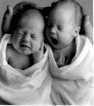

GEMMA & AMELIA ROSE
Gemma (6 weeks), Amelia Rose (11 weeks)
1993

Gemma is the baby who is asleep. Amelia Rose is the same baby who is in "Country Pumpkin". I was surprised when she opened her eyes and looked straight at the camera. Normally I photograph newborn babies asleep, because their eyes are still not focused properly, and tend to go in different directions. Amelia Rose looks very wise. She almost seems to be smiling at me.

Never plan specifically to photograph a baby yawning – because they'll never do it for you on cue.

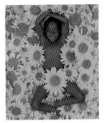

SUNFLOWERS
Zac (5 years)
1992

Here's Zac again. He had just the personality to fit with those sunflowers.

CLOWNS
Stephanie, Ashley, Elizabeth, Grace, Charlotte, Yuko, Jessica, Kelly
(5–9 years)
1993

We had a lot of make-up artists for this shoot so we wouldn't keep any of the children waiting around. Little children lose patience and enthusiasm very quickly, so the trick was to keep everyone excited about the shoot and also to get it over with as quickly as possible. My two daughters are also in this image.

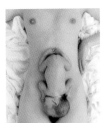

FULL TERM
Josie (4 weeks)
1994

I particularly love this image. Out of respect for new mothers who are trying to get back in shape, Linda is not the mother of this baby! I am always fascinated with the concept of unborn babies developing in the womb in such a compact space, and I think the image above demonstrates this beautifully. The little baby, Josie, was in fact one of twins, and they had been born early. The day of this shoot was very close to their actual due date, hence the name "Full Term."

REBECCA
Rebecca (14 months)
1991

She didn't want to hold the tulips, and she didn't want to sit on the chair – there were too many other things to be done. How do you get a 14 month old to sit still? Show her the jelly bean, and then put it down her trousers.

DRIFTWOOD FAIRY
Benjamin (3 weeks)
1996

Benjamin is the son of one of our publishers, so I wanted to make sure he was included in one of my images. He got to star as the "Driftwood Fairy," and at 3 weeks old he carried off the role with aplomb!

NEIL & TOMMY
Tommy (5 days)
1991

Unless they have had first-hand experience as a parent, some people have never had the opportunity to hold a brand new baby. Often when they are given the chance, they just seem to glow.

Of course, there are always practical considerations. Behind the scenes, things are often not always as they seem! If you look carefully, you'll see a little trickle running down Neil's arm. True to Neil's nature, his reaction was spontaneous laughter. *The lower image is not in the main part of the book.*

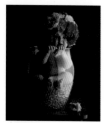

ROSES
Christopher (7 months)
1995

It was impossible to find a ready-made glass vase for this shoot, as it needed to be quite large to accommodate a 7 month old baby. In the end, I had to have the vase especially hand blown. Christopher was the only boy out of the five babies we had at the studio. They were all more or less happy to sit in the vase, but I thought he looked the best in that hat! What you cannot see is that he is sitting on a pile of soft plastic wrap (plastic for practicality!) and not the glass balls, which have just been placed at the front of the vase. A lot goes on in the background in the making of my images, to ensure the comfort of the babies.

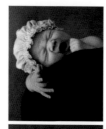

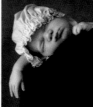

LOCHIE
Lochie (3 weeks)
1993

Lochie had been in for an earlier shoot, and his mother, Lisa, was just about to leave when he fell asleep on her shoulder. Lochie is the older brother of Caleb, who features earlier in the book.

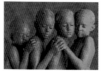

MUDPEOPLE
Jordan, Trent, Amber-Marie, Joel
(5–8 years)
1992

The day of this shoot dawned as the first cold day of the year. These children are all related. Trent and Joel (second from left and on the right) are twins. Between them is their sister Amber-Marie, and on the left is their cousin Jordan. They were all really enthusiastic about the shoot, and very good about being covered in a mixture of moisturising cream and potters' clay. Into the bargain, the clay kept drying, so we had to spray them with water during the shoot. When it was over, there was a mad scramble for the bathroom!

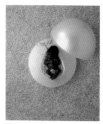

BLACK PEARL
Adam (2 weeks)
1994

This was an amazing shoot. These are real pearls – ten million dollars worth, in fact. The little Aboriginal baby is from Darwin, in the Northern Territory, Australia. Once again, we had to transport the large pearl prop from New Zealand to Australia for the shoot. Customs in all of the countries we visit for shoots must think I am a little strange.

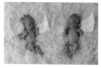

ALEXANDER & HARRY AS ANGELS
Alexander, Harry (3 weeks)
1995

There was a six month period during late 1994/early 1995 when I was shooting an angel calendar. There were feathers everywhere. Duck feathers, goose feathers, chicken feathers, every feather imaginable. Alexander and Harry are twins. You'd think it would be easy to get them to sleep in a feather bed, but in fact it wasn't, as the feathers kept tickling their feet, their ears, you name it!

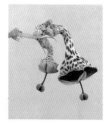

PARACHUTE FLOWER
Elise (newborn)
1995

I was still shooting *Down in the Garden* at this stage. We were visiting my friend Rhys Jones, who had grown the giant "Country Pumpkin." Mrs Jones always had wonderful homemade shortbreads on hand for our morning teas on the verandah, where we'd sit and look out over the next batch of giant pumpkins ballooning in the front paddock. Just as we were leaving she said, "Oh, I think I have something you might like," and brought out this tiny flower. It's a "parachute flower," from a little vine which was growing on their front porch, and is only about 3 cm long. Elise, the baby in this image, is the twin of Thomas, who is the monarch butterfly in a previous image.

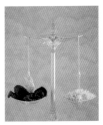

ANTONIE AS AN ANGEL
Antonie (5 weeks)
1995

Part of my feather phase, this shoot was done in San Francisco. When Antonie came into the studio on the day, I knew he'd be perfect, but thought he was a little too large to fit! I think he was nearly 6 weeks old, far too old to be such a good sleeper in a photographic studio. But it was one of those special (and lucky) moments, and the only time in your life really when you can have all those rolls, and people think it's cute.

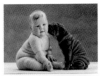

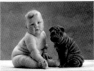

MARK & PUPPY
Mark (8 months)
1994

I had four Chinese shar-pei puppies in the studio for the shoot.

Mark was trying to chew this puppy and the other puppies were trying to chew everything else. Towards the end of the shoot all of the puppies fell asleep.

FOUR ANGELS
Khaleah, top (3 weeks), Annabelle, bottom (5 weeks)
1996

These two images were shot as complementary mirror images of each other. Jacob (holding Khaleah), above, was photographed in San Francisco, and Tony (holding Annabelle), below, was done in Auckland.

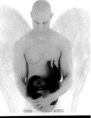

ALEXUS & ARMANI AS ANGELS
Alexus, Armani (9½ weeks)
1995

Alexus and Armani are twins. It was fortunate that we managed to get them both asleep at the same time, as they were 9½ weeks old, older than most of my sleeping newborns. As a general rule, I try to only use babies under 4 weeks of age in sleeping shots.

FIELD MICE
Mitchell, Taylor (5 weeks)
1995

These shoes were especially made for the shoot. They are size 22. Mitchell and Taylor are twins. Mitchell (on the left) was snoring at the time.

ANGEL NURSERY
Michelle, Catherine, Savannah, Foster, Roydon, Nicole, Jesse, Tamika, Annabelle, Brynn, Mikala, Georgia, Christopher, Courtney, Elisha, Benjamin, Dana, Emily, Ebony, Meredith, Helena (newborns)
1995/96

This image has been put together on computer, although people have asked me what the secret is to getting so many babies asleep at the same time! If I knew the secret to getting even one baby to sleep on cue, believe me I'd tell it to every new mother in the world!

ALEXANDRA & MYLES
Alexandra, Myles (7 months)
1993

Alexandra and Myles are twins who came to the studio for a portrait sitting. To me they have such wonderful faces – almost like

the original Pears babies. Notice the rolls down their arms and legs, and their fabulous tummies. Every time I look at these images, I just want to pick them up and hug them. They are the very essence of what I love about babies.

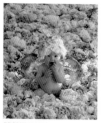

BARBARA & MAYNARD
Maynard (newborn)
1994

Barbara is not the mother of this baby. Her own baby had been into the studio a few weeks earlier, for another shoot. But she had such fabulous hair that I asked her if she'd model for me. Maynard had that suppleness unique to a newborn.

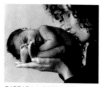

PEONY ANGEL
Danielle (6½ months)
1995

Congratulations are due here to Danielle, starring as the "Peony Angel." Most people would feel slightly daunted by competing with a whole bed of peony roses, but it didn't seem to faze her at all, and she's definitely outshone the competition.

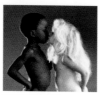

ZAC & GEORGINA
Zac (4½ years), Georgina (3 years)
1991

It's always very important to me to create a fun, relaxing environment for older children during a shoot. I think that most young children don't really have a concept of their image on film, nor are they interested in the end result. They are far more interested in just having a good time. If they are enjoying themselves, they are more likely to be totally spontaneous. Zac and Georgina got on really well, even though they had never met prior to this day. They both had such wonderful personalities. I try to get everybody involved in the shoot, including the parents. To me, my shoots are always a team effort.

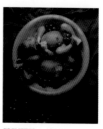

EBENEZER & ADNAN
Ebenezer, Adnan (newborns)
1992

To find two newborn African babies in Auckland at the same time was a miracle. I had been doing a local radio interview, asking for people with babies of different nationalities (in particular African babies) to contact the studio. There was no response, and then we got a call from a man with a mobile phone, who was riding on a bus. He said there was a very pregnant African woman at the last bus stop. So we rushed down there, and of course she'd got on a bus and left. Over the next few days we went to every corner store in the area to ask if anybody knew her. Then one day my Studio Manager drove past an African man who was riding a bicycle. He turned out to be the baby's father, and he and his wife had a friend whose baby was due at the same time. They were all from Ghana.

On the day of the shoot, both babies slept through the whole thing. As is often the case with my shoots, preparation is everything. I just try never to give up on an idea, despite the difficulties involved.

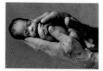

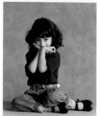

MANEESHA & JACK
Maneesha (7 weeks premature),
below (4 years)
1993

Maneesha weighed just over 900 g at the time of the shoot. This image was taken in the neo-natal ward at her hospital. She was born prematurely at 28 weeks' gestation (weighing 680 g), and was just about to leave hospital after her long stay.

Jack, who is holding her, has huge hands. At the time, he was working as a groundsman at a local school, so his hands were also very weathered. I had placed an advertisement in the local paper for a man with "very large hands, for a photo shoot." As you can imagine, we had some very interesting replies. People even sent outlines of their hands by fax! I auditioned about 10 men, and Jack's hands were the second largest, but he had a warm, gentle personality, which was essential for the shoot.

Maneesha is now a very healthy 4 year old, and has a baby brother. *The lower image is not in the main part of the book.*

123 POTS
(6–7 months)
1992

I could probably write a book about what it took to achieve this image. The organization behind the scenes, for weeks beforehand, was enormous. The whole shoot, in fact, had been scheduled for six months earlier, when we had booked 6 month old babies (160 of them!), and we were a few days away from the shoot when a measles epidemic hit Auckland. As 6 month old babies are not inoculated for measles, having 160 children together at that time in a garden hot-house just wasn't an option. So we canceled the whole shoot, and I nearly didn't do it again, mainly through lack of intestinal fortitude!

However, the thought of all those little bald heads peering out of the flowerpots drove me to it, and it was certainly worthwhile in the end. Each flowerpot has a little foam pillow inside, and the babies were probably in the flowerpots for about two minutes. From the camera angle, it appears as if the pots are all really close together, but in fact there is walking space between them. A parent stood by each pot with their baby, and all the babies were placed in the pots at the same time, before the parents walked away to the side. You can see that some of the babies are looking to the left of the image. This is where the parents were standing. To the right of the image, one of my assistants was

waving a big bunch of balloons to try to distract everybody (not necessarily with much success). Of course, once one started to cry, others joined in.

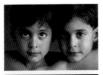

TRENT & JOEL
Trent, Joel (6½ years)
1992

What I love about twins, as is evidenced in this image, is their closeness. Trent and Joel were naturals. With their beautiful faces, it was hard to take a bad photograph of them. They modeled for me a number of times when they were around this age and, along with their sister and cousin, became my "Mudpeople," an image featured earlier in this book.

BATHTUB BABIES
Claire, Alexander, Hazel, Jamie, Madeline
(6–7 months)
1992

I've found that 6–7 month old babies generally don't like sitting too close to each other, and into the bargain have very short attention spans. For a shoot like this, there are always twice (or even three times) as many babies as are needed on hand, so if anybody didn't want to sit in the tub, it wasn't a problem. Babies, in general, have no respect for photographers' plans. When they decide the show's over, it's definitely over!

ALEESHA & JESSIE
Aleesha, Jessie (3 years)
1992

Aleesha and Jessie are twins. I photographed them a number of times when they were about 3 years old, because they were so delicate, and had such wonderful hair.

SWEET PEAS
Holly (11 days), Thomas, Elise, Nana Yaw, Sophie (4 weeks), Rebekah (3 weeks)
1995

This is not a computer image. The babies are actually lying in soft cloth pods, on top of 60 kg of green peas. Each page is a separate image, so I suppose you are looking at 120 kg of peas altogether, with different babies inside the pods. Getting the babies asleep at the same time wasn't really too difficult. On the "difficulty scale" of 1–10, this was probably about a 4, as newborn babies love to be wrapped snugly.

If you are wondering what we did with all those peas afterwards, they went to the Auckland Zoo, to feed the elephants.

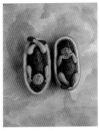

WATERMELONS
Cara (4 weeks), Danielle (2 weeks)
1995

Finding the watermelons for this image was the difficult part. With much smaller families these days, there is no demand for large watermelons, and therefore they

are quite rare. We went to two early morning fruit markets (the 5 a.m. ones!) before we found two watermelons this size. The watermelon costumes were really beautiful, with real watermelon seeds incorporated in them. The babies were lying on top of plastic and soft foam, so they were very warm and dry, and to get them to sleep we walked around with them as they lay in the watermelons.

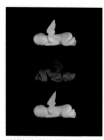

JOHN AS AN ANGEL
John (6 weeks)
1996

John, the only real baby in this image, modeled for the two pale angels a few days before the shoot so they would be identical to him. So the trick at the shoot was to have him sleeping in the same position. He was quite happy to sleep, but he didn't want me to move his hand! That's fine.

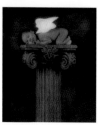

VARJANARE AS AN ANGEL
Varjanare (4 weeks)
1996

The wings are attached to a small piece of wire, which is attached to the back of the pillar. They are made of foam, so they're very light, but they had to be carefully lowered onto the baby's back without waking her. I wonder if this is how real angels keep their wings on?

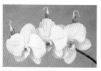

MOTH ORCHID
Alesha, Chantelle, Kailee (8 months)
1994

Alesha, Chantelle and Kailee are triplets, in case you thought I photographed the same baby three times. They were almost identical – like little china dolls – and they all had the same expressions!

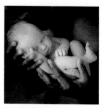

TONY & KIRSTEN
Kirsten (newborn)
1993

I love the contrast of skin tones in this image. What is clearly evident is the attention, love and care of an adult towards a young child – you can just see it in the hands. Young life is very precious.

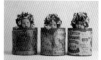

PANSIES
Aisha, Tayla, Grace (6–7 months)
1995

This is an image from *Down in the Garden*. The idea for the pansy tins came from a story that Natalie, my Studio Manager, told me about when she was little. She was out in her grandmother's garden when she was about 3 years old, and bent down to pick a pansy. Her grandmother, who was gardening at the time, hid behind a bush. Just as Natalie was about to pick the flower, she heard what she thought was the pansy say, "Oh please don't pick me," in a tiny little voice. So you see, pansies really do have faces.

STEEL ROSE
Adam (8 weeks)
1995

The long, slender stem of the steel rose was flexible, so we rocked Adam gently to sleep. You can see by the curve of his tiny tongue that a pacifier had just been extracted (a delicate procedure that should only be attempted by experts, and certainly not the fainthearted).

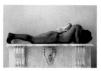

EDDIE & SARAH
Sarah (newborn)
1993

Eddie has been used in many of my images because he works so well with babies.

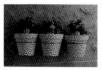

GERANIUM POTS
Olivia, Justine, Meg (7 months)
1993

This image was on the cover of one of my calendars in Australia and New Zealand. I personally

painted the white spots on these pots, back in the days when I didn't have a talented team of prop makers and life was more simple! The three pots were all mounted on a steel structure on a wall in the studio.

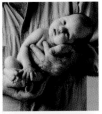

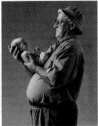

FRED & AMELIA ROSE
Amelia Rose (11 weeks)
1993

Amelia Rose is the same baby who is on the "Country Pumpkin." Fred is her very proud grandfather.

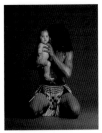

LAWRENCE & SHARAI
Sharai (6 months)
1991

Lawrence is a Maori wood-carver from Auckland. Here he is, wearing a traditional Maori piupiu, with his baby daughter, Sharai.

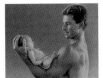

NEIL & TOMMY
Tommy (5 days)
1991

Neil, the big person in this image, did my black and white printing for many years, as well as being a good friend. He passed away in December 1996, at 38 years of age, and we all miss him dearly. He is holding Tommy.

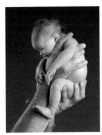

JULIA
Julia (6 days)
1992

This little baby is Julia, who was the unborn baby in the image of Mary's pregnant tummy (later in this book). Julia was less than a week old. She is being held by Dr. Gaby Tetro, who was a well-known family doctor in Auckland.

TAYLA, ASH, LUKA & NIKO AS ANGELS
Tayla, Ash, Luka, Niko (6 weeks)
1996

Tayla, Ash, Luka and Niko are quads. Just before Christmas 1996 I saw a newspaper article about their birth. I contacted their parents, and we did this shoot in their living room at home, just after they had arrived home from hospital. Two of the sets of hands holding the quads belong to their mother and grandmother.

CROCODILE TEARS
Sarah (13 months)
1990

Sarah came in for a portrait sitting, and I sat her on a large box. She was a little unsure about everything, and was startled when the first flash went off. I think this image is lovely, because of her beautiful expression – a tiny, uncertain smile, and a tear as well.

SLIPPER ORCHID
Brooke, Starcia (8 months)
1994

This is another image from *Down in the Garden*. Brooke and Starcia are twins, and they had the most amazing eyebrows. They also seemed to have identical expressions.

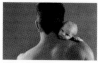

NEIL & TOMMY
Tommy (5 days)
1991

This is Neil, with Tommy again. Newborns always have eyes which they can't quite get to focus, which is probably why they sleep so much – it's just easier!

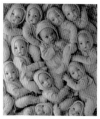

LIVING DOLL
Michaela (10 weeks)
1993

A magazine in New Zealand published a photo of me holding one of these dolls so we could start a search for a baby who would blend with them all. We had a huge response, with people from all over the country sending in photos of their babies. Of course, not many of the babies looked like the doll. In fact, some of the babies were about 2 years old! In the end, we auditioned around 30 babies, who were all very close, and three of these babies came to the shoot, but Michaela was perfect on the day. The amazing thing was that, after a New Zealand-Wide search, we ended up with a baby whose mother worked three doors down the road from the studio!

SCOTT ON NAPPIES
Scott (4 weeks)
1993

Scott has a twin sister Josie. I had already photographed Scott as my "Sleeping Lion," so this shoot was actually intended for Josie. However, she had other ideas!

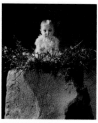

BABY BALD EAGLE
Olivia (7 months)
1993

This image is very special to me. Little Olivia, my "Baby Bald Eagle," tragically drowned about a year after this photograph was made – we were all devastated. I thought that perhaps her parents would not want the image published afterwards, quite understandably, but her mother said that she wanted to see Olivia's beautiful face everywhere, as a celebration of her life. So Olivia's photograph in *Until Now* is dedicated to her family.

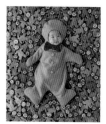

GINGERBREADS
Monica (2 months)
1993

My assistant at the time spent all weekend baking these gingerbread men, because I couldn't find a baker who wanted the job! It certainly smelled delicious from my vantage point near the ceiling. After the shoot we sent all of the gingerbreads to the children's hospital nearby.

POPPY
Alexander (5 weeks)
1995

I love the way poppies open so quickly, right in front of your eyes.

WOODLAND FAIRIES
Nathan, Nga Roi Mata, Alexandra, Alana, Corey, Georgia, Michael, Larissa, Adriana, Brooke, Cory, Rayne, Benjamin, Adam, Kurt, Pearse, Jarrad, Trent, Travis, Holly, Maddux, Kendra, Amber, Jessica, Jasmine, Jamie Leigh
(newborns to 6–7 months)
1997

There are 26 little woodland fairies in this image. All of the babies were photographed separately over two days. The wood and various other items for this image were collected during trips to beaches around Auckland over a two month period, and it took a week to get everything exactly into position. I photographed the wood scene before the babies, and each baby was then photographed in an individual pose, to exactly fit their positioning in the final image.

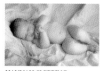

HANNAH SLEEPING
Hannah (7 months)
1991

This is an image from one of my very early portrait sittings. Hannah got fed up with being photographed, and dropped off to sleep.

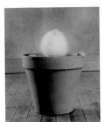

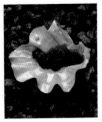

ROCK OYSTER
Alexis, Rochelle (6 months)
1993

From this image, you can't tell how hot it was up on Bathurst Island (in the far north of Australia) in the peak of summer. After driving in an old four-wheel-drive with no hand brake, digging up rocks on the side of a hill, with the red ants crawling all over us, the photograph was the easy part!

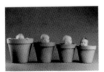

4 POTS
Stuart, Tessa, Thomas, Johnathon (6 months)
1991

This is the very first image I ever took using flowerpots. In fact, I wasn't sure which was the ideal size pot for a 6 month old baby, so had bought four different sizes to try them out. What I like about this image is that there is so much going on with the babies.

CACTUS
Chelsea (6 months)
1991

It was winter, and a few weeks after I had taken the shot with the four pots, Chelsea came in for a portrait session in the fluffy hat. When I sat her in the pot, she looked just like a little cactus plant.

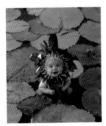

WATERLILY
Tayla (6 months)
1995

Would you believe that one of the babies who came in for this shoot was called Lily? But, of course, babies being babies, Lily didn't want to be the lily of the day and, anyway, Tayla was happy to sit in the pond – she even thought the leaves were quite tasty.

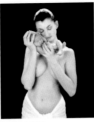

LINDA & BEN
Ben (2 weeks)
1994

Linda, holding Ben. Linda also featured earlier in the book in the image "Full Term."

SPIDER'S WEB FAIRY
Starzia (6 days)
1997

I was jogging one day in autumn, and came around a corner to see an old autumn leaf hanging from a spider's web in front of me. It was late afternoon, and the light was beautiful.

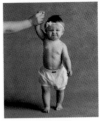

AUNTY BIDDY'S FACE
Jessica (1 year)
1996

This is Jessica's own personal version of her Aunty Biddy's face. I'm not sure how Aunty Biddy feels about this.

AUTUMN LEAF FAIRIES
Christiaan, Annaliese (18 days)
1996

These autumn leaves were all hand made out of latex. It would have been easier to do this on computer but, if possible, I prefer not to manipulate an image. Christiaan and Annaliese are twins. I love this shot because of their little round tummies.

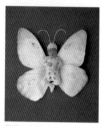

FIONA BUTTERFLY
Fiona (3 weeks)
1995

Fiona's parents used to be my next door neighbors. Her mother is Japanese, and her father is Malaysian. They have three beautiful daughters.

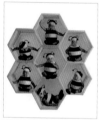

BUMBLEBEES
Matthew, Antoine, Dominique, Jabari, Gabriel, Dionte, Gabriella (7–12 months)
1993

This is the first shoot I ever did in the United States. The honeycomb prop was made in New Zealand and transported to San Francisco. For this image, there were twice as many babies on hand, all dressed in bumblebee suits, so if one baby cried, we could quickly take them out and replace them with another bee. Behind each baby there was a small pole built into the whole structure, and at the back of the bumblebee suits there was a very large velcro seatbelt, which went

around the pole, to keep the babies safely in place and make them feel very secure.

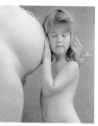

MARY & CHARLOTTE
Charlotte (5 years)
1992

I have been wanting to publish this image for a long time, as it is one of my favorites. The little girl, Charlotte, is the sister of the unborn baby, Julia, who featured less than a week after her birth in one of my images earlier in the book. Since then, Mary has had another baby girl, Elizabeth.

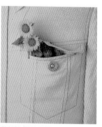

SMALL CHANGE
Jane (5 months)
1994

This is not a computer image. The fabric for the pocket was chosen especially to work to scale, and the stitching made larger as well, so the whole effect would be of a real denim jacket, close-up.

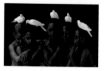

BOYS & DOVES
James, Diontah, Niam, Greg, Mutunga (7–10 years)
1993

We found these trained doves in San Francisco for the shoot. The boys said to me, "They won't do anything on our heads, will they?" "Of course not," I replied. In fact, the boys were wonderful. They were so excited about the shoot, it was hard enough to calm them down, let alone have doves sitting on their heads.

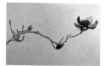

MAGNOLIA
Caitlin (5 weeks)
1994

This is a computer-manipulated image, although many people have said to me, "Where did you get a flower that big?"

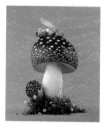

TOADSTOOL FAIRY
Erin (2 weeks)
1994

This toadstool was especially made to have a very wide top, which was lined with foam. I often think I'll have to set up a prop museum, as our storage area is growing larger and larger, and I am always reluctant to throw things out. The toadstool is so realistic, and is a tribute to my prop maker, Dawn McGowan. We have been working together for many years. Every shoot is a challenge to her, and she never fails to come up with something wonderful.

KIERAN & ABIGAIL AS ANGELS
Kieran (1 year), Abigail (11 months)
1996

I found this wonderful old concrete pillar in a garden shop near the studio, and it was so old and heavy that we had to shoot on location. Besides, I also liked the wall behind it. Generally, I don't like to do location work, as I prefer a more controlled, comfortable area for little babies on a shoot to be waiting in. They need quite a lot of room to spread out – in fact they are prone to taking over whole studios – and it can get quite noisy. So we did the shoot before the store opened. Kieran and Abigail are Down syndrome babies, which is completely irrelevant to the photograph, but I wish more parents of these little ones would send in their photographs as a matter of course, so I can include them in more of my images.

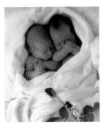

MILLY & NATALIE
Milly, Natalie (4 weeks)
1993

Milly and Natalie are twins. As I've said before in my comments about Trent and Joel (featured earlier), I think twins are very special. Newborn twins in particular often feel very secure sleeping next to each other. They just seem to mold together.

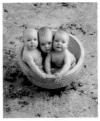

JIM, FLORA & PEARL
Pearl, Jim, Flora (8 months)
1994

Jim, Flora and Pearl are triplets. Jim is actually in the middle of this image, Pearl on the left, and Flora on the right. Their mother laughingly called them the "spew crew." Jim still wasn't very good at sitting on his own, so the girls are lending him support. This image is from my book *Down in the Garden*. In the book, the caption with this image read, "Don't forget to separate your bulbs before they become too crowded." Jim perhaps wouldn't have wanted that at the time!

ACORN BABIES
Thomas, Evan, Dean, Elizabeth (newborns)
1994

The tops of acorns always look to me like little hats, and inspired this image. It has been computer manipulated (oh really?). I especially like the little twins (Evan and Dean) who are lying together – they look as if they could have been still in the womb. In fact, the other two babies in this image, Thomas and Elizabeth, are also twins.

THANK YOU

I would like to extend my gratitude to the following people, for their contributions to the success of my work.

Kel Geddes, my husband and partner, for helping to give my images such incredible exposure and support.

Terry McGrath, our friend and Chief Executive Officer, who also helps to manage the brand worldwide.

Natalie Torrens, my Studio Manager for the past seven years, who is there for every shoot, and probably loves babies as much as I do.

Dawn McGowan, who has worked with me as my prop maker/stylist since 1993. Her talents know no bounds.

Relda Gilbert, our Production Director, who controls the quality of film and printing worldwide.

The team who give so much to ensure that the values we promote are constantly nurtured, wherever my images may be used. Rebecca Swan (black and white printing), Rachel Little, Estelle Murray, Andrea Pickett, Jo Ormrod, Kelly Skelton, Megan Daggar, Francey Young, Angela Mobberley and Holly Babuik.

And, most importantly, I am deeply appreciative of the trust and responsibility given me over the years by the many parents who have come to my studio and unhesitatingly handed me their very tiny and very precious babies. Your faith and confidence in me is never taken for granted. In fact, every single time I hold a newborn baby I feel that I must be the luckiest person in the world.

You must work — we must all work — to make

he world worthy of its children. Pablo Casals

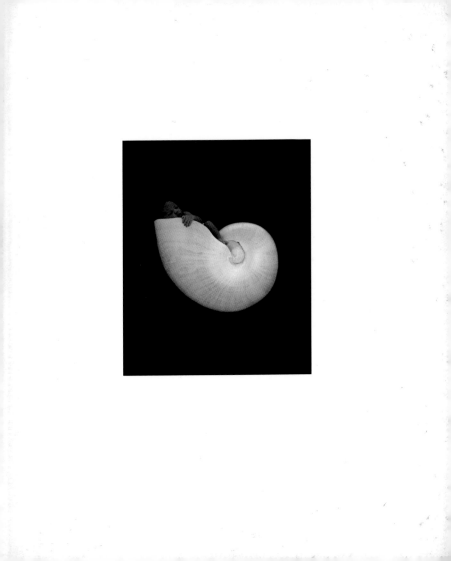

ANNE GEDDES ®

www.annegeddes.com

© 1998 Anne Geddes

The right of Anne Geddes to be identified as the Author
of the Work has been asserted by her in accordance with the
Copyright, Designs and Patents Act 1988.

This edition published in 2003 by Photogenique Publishers
(a division of Hodder Moa Beckett)
4 Whetu Place, Mairangi Bay, Auckland, New Zealand

Published in North America in 2003
by Andrews McMeel Publishing
4520 Main Street, Kansas City, MO 64111-7701

Designed by Frances Young
Produced by Kel Geddes
Printed in China by Midas Printing Limited, Hong Kong

ISBN 0-7407-3541-1

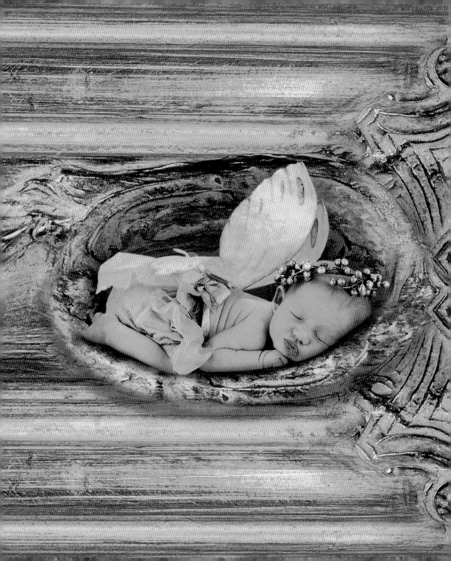